Vincent
Van Gogh

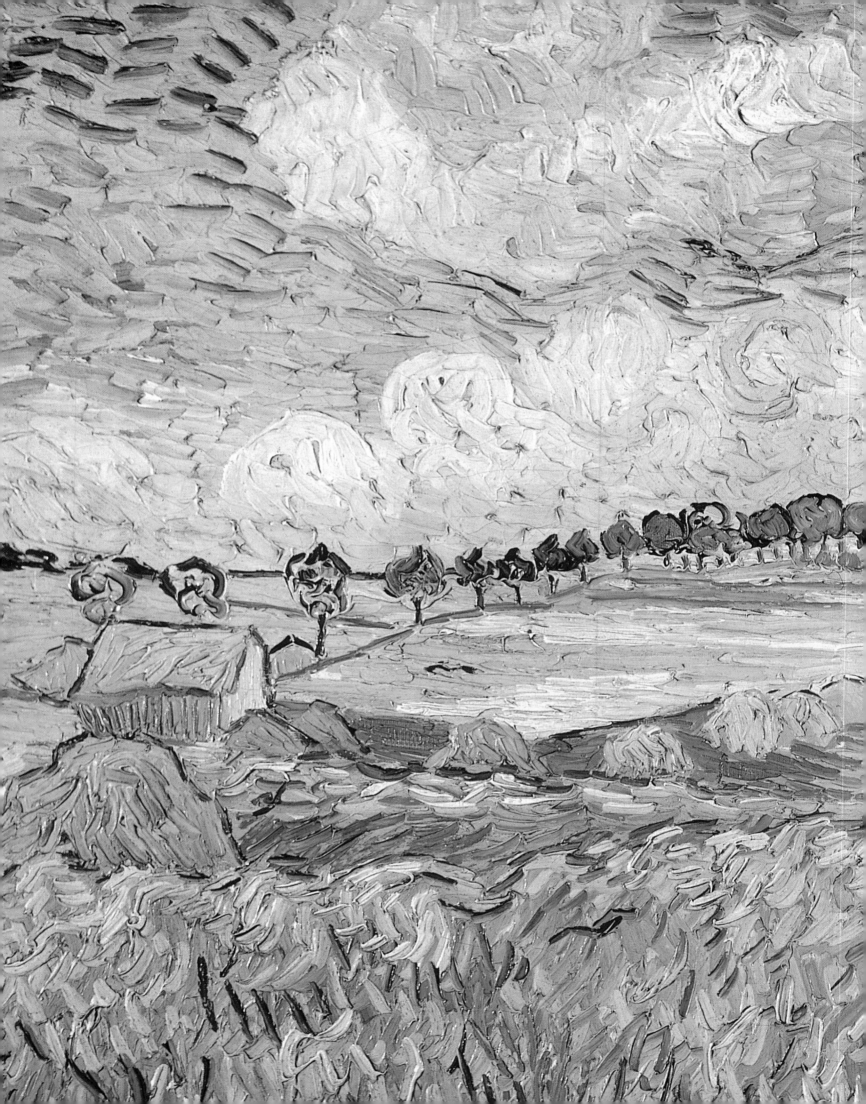

Vincent
Van Gogh

Trewin Copplestone

GRAMERCY

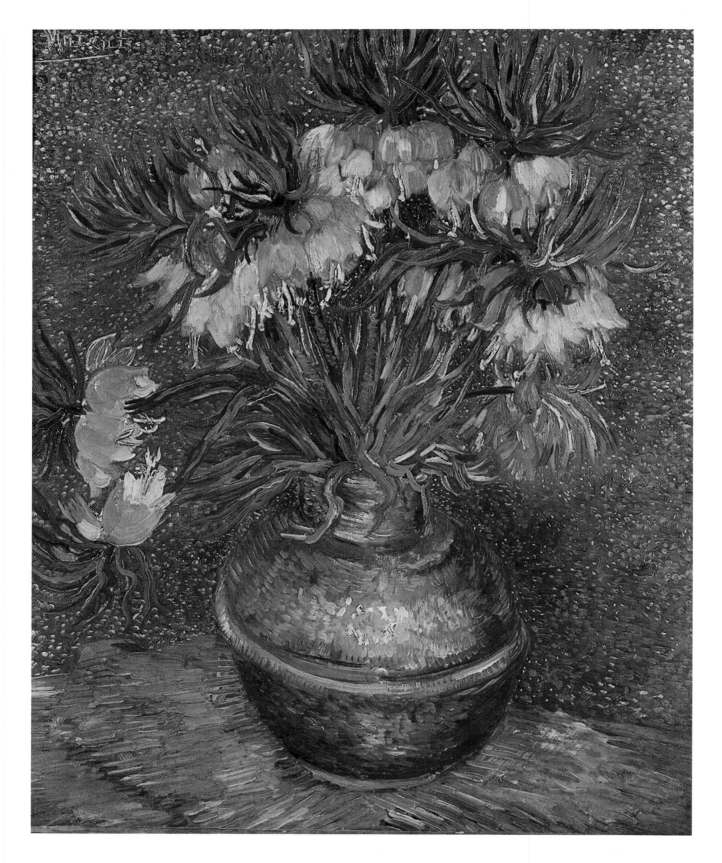

Random House New York • Toronto •London • Sydney • Auckland
http: / / www.randomhouse.com/

Printed in Italy

ISBN 0-517-16054-4

10 987654321

List of Plates

If price is the measure of value, Van Gogh is one of the greatest of all painters – at this moment. Of course, the price of an object is, in one way, a valid indication of a real commercial value. Whatever the price of anything, if it sells someone wants it and that in itself creates one criterion of value. With most manufactures, its selling price is at least related in some way to the cost of its manufacture, including materials plus a profit margin. Such costs go up and down and prices go up and down – or should – although they appear to have more of a struggle going down than up.

But in the art world the problem is much more complicated and evaluations more unreliable. Of course, the same principle of supply and demand will operate and Van Gogh's work commands world record prices, reflecting an intense demand for what is a limited, finite supply. Here it is necessary to consider not only the number of paintings produced but the remaining number available – many are not for sale at any price. Perhaps the first point to make is that, unlike the manufacturing situation, the product cost, canvas and paint bears little or no relationship to the price. There is an added perceived value by association. If it is a Van Gogh it is, by definition, currently worth a fortune. Of course it was not always so – Van Gogh sold only one painting in his lifetime, and that for only a few francs. From this it becomes apparent that the value of the object, already established as unrelated to its physical cost, is also related to its perceived value. The attributed value of most artefacts, including paintings, is subject to considerable fluctuation, both up and down.

Despite what might properly be described as a failed career in painting it is extraordinary to realize how quickly Van Gogh's reputation improved after his death. Articles, exhibitions, catalogues and, later, books (of which this is a small example) have poured into a voracious marketplace since before the First World War and the process, it has to be acknowledged, continues. The story of Van Gogh's life, tragic in its actuality and glorious in its legacy, continues to fascinate. It is also worthwhile noting that despite lack of sales and public recognition, the enthusiasm of one or two admirers, the willingness of galleries to show his work and the representation of his work in many mixed shows indicate that he was not an unknown painter during his working life. He knew many, if not most of the artists that we would regard as important today, and even if many of his contemporaries regarded him as in some way a little odd or strange, his work did interest many people. The fact that he sold only one painting would appear to some as failure. This was not so: from the very first Van Gogh was regarded by some as a genius.

Van Gogh worked as an artist for at most ten years and of those years only the last four produced his most representative works. As early as 1884 he said to a friend: 'I certainly hope to sell in the course of time, but I think I

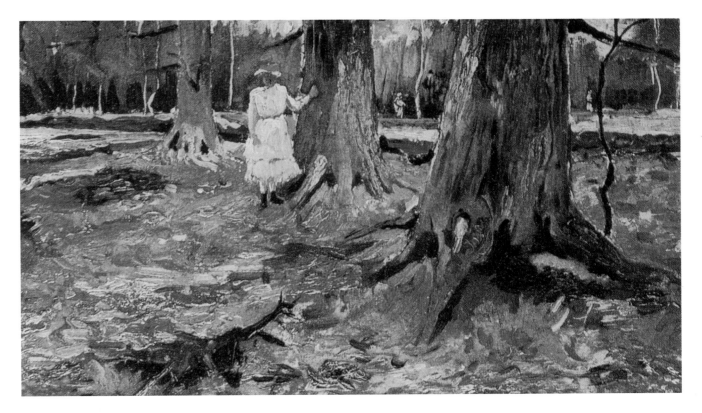

shall be able to influence it most effectively by working steadily on, and that at the present moment making strenuous "efforts" to force the work I am now doing upon the public would be pretty useless.' Ten years is not a lengthy career and although Van Gogh wished and indeed, tried to sell his work, he realized that he was making progress in his work and required more time to arrive at his full achievement. It might be argued that his unsatisfactory life was his own fault and that his suicide was an admission of defeat or inadequacy, but equally, recognizing his temperament and mental condition, it might be that he was unable to overcome the pressures imposed by his intense, creative nature.

In the course of studying his life, nevertheless, we shall have to consider why Van Gogh is now so highly valued, why he was not in his lifetime, and whether he is as reliable a long-term investment as at present he evidently appears to be. This last point is of considerable importance and many self-interests are involved. At this moment there is an intense debate concerning one of Van Gogh's works recently sold for a very large sum of money and now being attacked as a forgery. If not a Van Gogh it will be worth only a little, as a curiosity, and someone is going to lose a great deal of money. But of course, though its provenance is in doubt, the painting remains unchanged and presumably still gives the same amount of pleasure to viewers being, after all, the reason why someone bought

PLATE 1
Young Girl in Wood (1882)
Oil on canvas, 15¹⁄₃ x 23¹⁄₄ inches (39 x 59cm)

Although Van Gogh began drawing with the serious intention of becoming an artist, it was not until the summer of 1882 that he began to paint in oils. This painting is interesting on this account alone since it is one of the earliest executed by him and it shows rather more basic accomplishment than he is usually recognized as possessing. Indeed, as his unsuccessful career advanced, his academic control was gradually replaced by his expressionist exploration in the few years of life he had left to him.

In this painting, his manipulation of thick impasto paint, the careful composition moving from the top left to the bottom right in a steady progression of trees suggests that there are more trees behind the viewer, with two effects. Firstly, it connects the viewer with the small isolated figure and secondly, draws the viewer into the picture space and the emotional tension of the young girl's pose. It is Post-Impressionist in its expressionist intention before Van Gogh was actually aware of the Impressionist movement.

PLATE 2
The Weaver/The Loom (1884)
Oil on canvas (probably on card), 14$\frac{1}{2}$ x 17$\frac{3}{4}$ inches
(37 x 45cm)

This is a subject that Van Gogh treated a number of times in different ways and on a different scale. It might be noted here that it was his practice to repeat most of his significant subjects with either small variations or make them almost identical (as far as possible). It seems that the reason that Van Gogh painted the Weaver subject a number of times, lay in his admiration of craftsmanship and simple machinery. As in other paintings of the period, he was interested in the Rembrandtesque effect of the artificial gas-light in which most of the weavers worked. He was also attracted by the silhouette of the figure and loom against the brighter walls.

PLATE 3
Road near Nuenen (1884) opposite
Oil on canvas, 30$\frac{3}{4}$ x 38 inches (78 x 97cm)

By the time that Van Gogh had returned to his new family home in Nuenen, the disturbing experience of the Borinage (page 23) was behind him and although deeply concerned in spirit, his palette lightened and the atmosphere in the landscapes he painted became less despondent and more expressive, as may be seen in this study. He is still employing a dark tonal scheme enlivened, however, by light touches of brighter colour in the foliage of the poplars. As usual, Van Gogh has introduced a figure to give scale to the scene and suggest the isolation of humanity in the great spaces of nature.

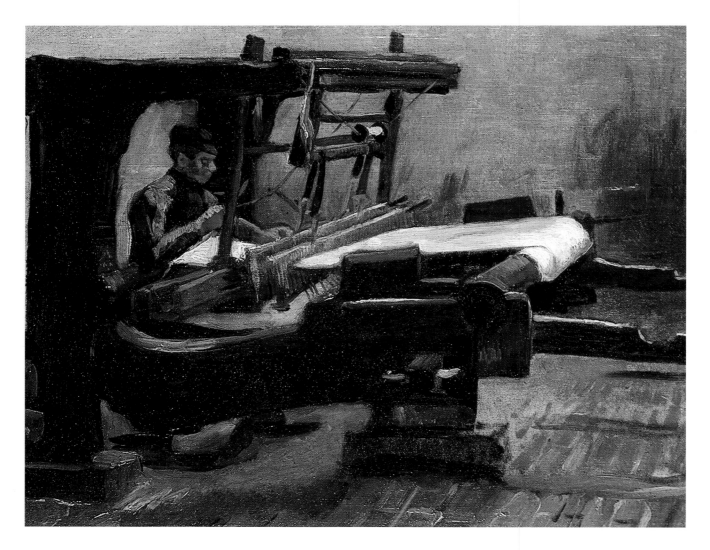

it. But since it has lost value, in some respects this is evidently not so – or perhaps the forger was as good as Van Gogh and the work does in fact have the qualities it was perceived as having when it was considered to be a Van Gogh.

It is also not unreasonable to suggest that many collect great paintings in order to surround themselves with an aura of culture, and it may not be so much a love of art as a desire to be seen as the possessor of such riches that is the prime motivation. In these egalitarian days, when the aristocracy is under threat, a hierarchy of culture may be emerging. If this is true, then it is unlikely that prices or works of art once established in this field (or publicly given for other cultural activities) will be allowed to diminish in value at the highest levels. The number of great American industrialists who are better known for their art collections than their ownership of railroads perhaps establishes this in a land where aristocracy has no relevance.

These comments and speculations are in no way original. They present a constant underlying apprehension that the distortions introduced by a hyped up art market are seriously damaging to full appreciation, and obscure the real qualities in any work of art. And these are independent of any price large or small. The story of Van Gogh's life is a poignant reminder of the familiar *ars longa vita brevis*.

Many artists of powerful and tortured spirit have had a short life of which Van Gogh's is perhaps the most dramatic example. While he was materially unsuccessful as an artist in his short, tragic life, ended by his own hand, his art has grown in popularity and professional esteem until he is now regarded with almost universal approval as of similar stature to such towering figures as Michelangelo and Rembrandt and these days his name, if not his art, is certainly as well known. What can have elevated him to these heights? Was he a precocious short-lived genius like Raphael, Masaccio, Caravaggio or Mozart? It is at least evident that he was less successful in life than any of these.

Vincent Willem Van Gogh was born in Groot-Zundert, a small village in Brabant, Holland, near the Belgian border, on 30 March 1853, the eldest son of six children of the Reverend Theodorus Van Gogh, the local Protestant pastor from whom Vincent inherited his deep and abiding religious faith, a sympathy for the harshness of peasant life, and respect and awe for nature and natural forces – evidence of all this to be later apparent in his work. His younger brother, Theo, was his closest friend, ally and supporter throughout his life and Vincent wrote to him regularly in letters full of passion, torment and accounts of vicissitudes and ambitions. The family household was happy, warm and affectionate. His father hoped that his eldest son would follow him, as he had his father, into the church. Vincent was, however, not by nature suited to be a pastor. Sensitive, but given to bouts

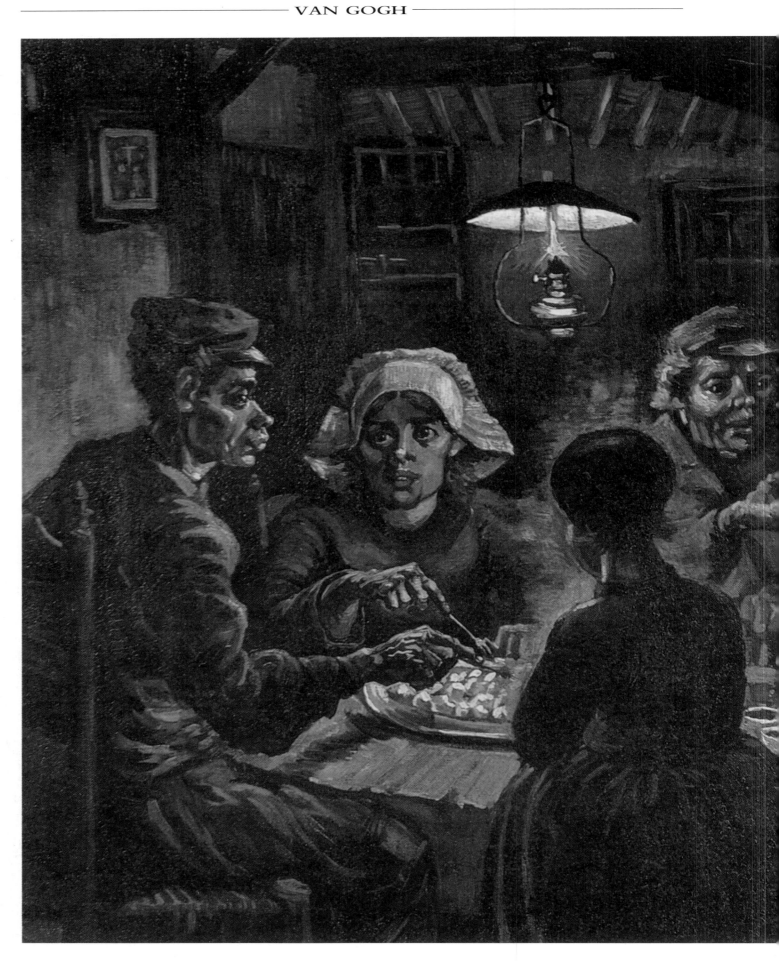

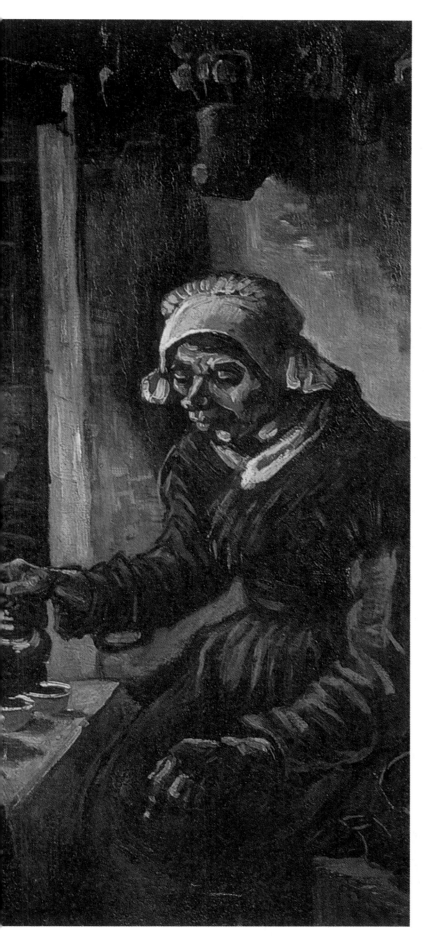

PLATE 4
The Potato Eaters (April–May 1885) detail
Oil on canvas, 31⁷/₈ x 44⁷/₈ inches (81 x 114cm)

This is the most significant of the paintings completed in the earliest period of Van Gogh's work. It reveals the sympathetic identification that Van Gogh felt for the peasants with whom he worked and lived. This is not a painting of observation or even of atmosphere, it is an engaged statement of the depressive nature of poverty. Painted in dark tones and a heavy coarse brushstroke, it carries echoes of Van Gogh's 17th-century compatriot, Rembrandt. In a letter to Theo he explained that he wanted to express a feeling that 'these people in the lamplight have worked the earth and that my painting gives dignity to manual work'. Most of his work during this time depicts peasants labouring in the fields or at a trade and he painted a number of versions of each subject, including several different versions of Potato Eaters.

of depression, Theo was his only close companion and natural confidant in the large household of parents, three girls and three boys, in which he undoubtedly felt emotionally isolated.

At the age of 16, in 1869, Vincent was recommended by an uncle for a junior clerical post in an art gallery in The Hague owned by the prosperous Parisian art-dealers and publishers, Goupil and Co. Initially he performed well but his temperament, alienated and uncommunicative, irritated his business associates.

Seeking reassurance, he began his close correspondence with Theo, one so voluminous and comprehensive that the minutest details of his life can be gleaned from these letters and Theo's replies. Despite their close relationship, there was a break in correspondence when Theo, himself a well-balanced and successful individual, became perturbed by Vincent's apparent inability to live his life in a reasonable and conventional manner.

Vincent must have performed his work at least adequately since he was transferred from The Hague to the London branch of Goupil's in 1873. The first of what seemed to him great tragic events occurred when he quickly fell in love with Eugénie Loyer, his landlady's daughter and one year his junior, who roughly rebuffed him when he summoned up the courage to ask her to marry him – he later learned that she was engaged to

PLATE 5
La Guinguette in Montmartre (1886)
Oil on canvas, 19¼ x 25¼ inches (49 x 64cm)

This was painted in Paris soon after Van Gogh's arrival, and before he had adopted his familiar high colour-key painting method. Sombre in colour and tonal in construction, this painting does not fully belong either to the early or later periods and *appears to be more an exercise or study, reflecting Van Gogh's first experiences of Paris and its social life. Calling it La Guinguette in Montmartre does not identify the location since guinguette is a general term for a small restaurant with music and dancing, usually with a pleasure garden attached. This view shows the scene from the garden side where the activity is hardly stimulating at the time of the day depicted.*

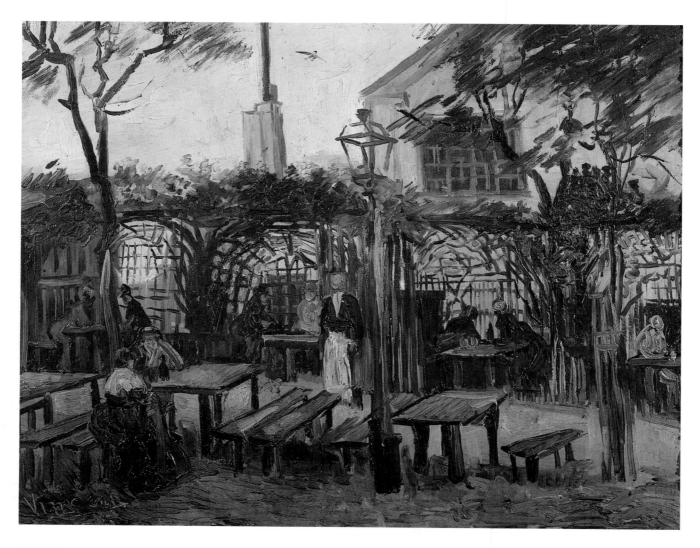

PLATE 6
Fritillaries in a Copper Vase (1886) detail
Oil on canvas, 28³/₄ x 23³/₄ inches (73 x 60.5cm)

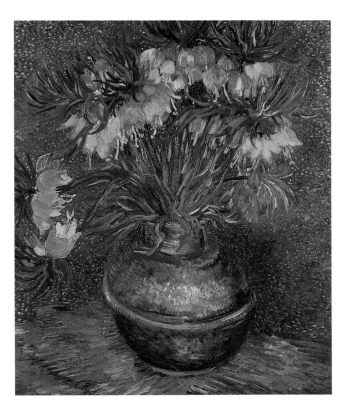

Painted soon after Van Gogh made his first visit to Paris, this already reveals the influence of both Impressionist and Neo-Impressionist techniques. There is a change of colour from the dark heavy impasto and sombre mood of the Borinage period to a more lively and cheerful effect. The brushstrokes are nearer to the more typical Van Gogh approach of short energetic strokes. The background shows evidence of the Pointillist/Divisionist dot application, relying on optical mixture for its colour effect – in this case, a green suggestion from the use of blue and yellow.

It might also be noted that the subject is chosen not for its human implications, but from a delight in the possibilities of a visually attractive scene with differing textures, that is the delicacy of the flowers against the solidity of the copper.

marry someone else. Vincent was then about 21 and the experience devastated him. Never confident by nature and like many another young man before and after him nervous and uncomfortable with women although with a strong sexual nature, his sense of insecurity and inferiority increased. He was miserable and lonely in London.

He returned to his parents for a holiday in July 1874, a month after the closure of the first Impressionist exhibition. His parents found him thin and dispirited and, encouraged by his father, he at last turned to religion. He was transferred from his job in London against his will and returned to the Paris office where he spent his evenings studying the Bible. Towards the end of the year he was posted back to London and tried again with the landlady's daughter but with no more success. By the time, in the following year, that he was called back again to the Paris office, he was in a state of such religious fervour and spending most of his time in solitary meditation, that he could not concentrate on his work, argued with his associates, and generally created such an uncomfortable atmosphere that he was asked to leave at the end of March 1876. Nothing was going his way and his natural depression was giving way to despair.

Almost immediately, Vincent returned to England, and with what could be seen as a new-found religiosity, became more hopeful and positive, seeing the opportunity of a new start. He took a teaching post in Ramsgate on the south coast, instructing pupils in elementary French, German and arithmetic (he was fluent in both languages as well as English). As usual with most of his ventures, he did not prove successful and lasted at the school for only two months. With his extreme preoccupation with religion combined with sexual frustration and a depressive temperament, it is perhaps not surprising that he proved to be a poor teacher. Nevertheless, he took another teaching post in Isleworth on the outskirts of London in another school run by a clergyman who, recognizing his deep religious faith, often used him as a preacher. In his introductory letter of application Vincent declared, ' ...the reason that I would rather give for introducing myself to you is my innate love for the Church and everything connected with it.' This taste of the religious life inspired in him a new, more aggressive religious zeal and a burning ambition to become a missionary.

Vincent returned again to his parents, now living in Etten, and his father, seizing the opportunity, gave him so much encouragement that he decided to sit for divinity entrance examinations in Amsterdam. From the first, he failed to master his curriculum which included Greek and Latin and in July 1878, at the age of 25, he abandoned his studies believing that he should embrace a more practical religious life. He consequently applied for an evangelical school in Brussels where he was given instruction in the

Continued on page 23

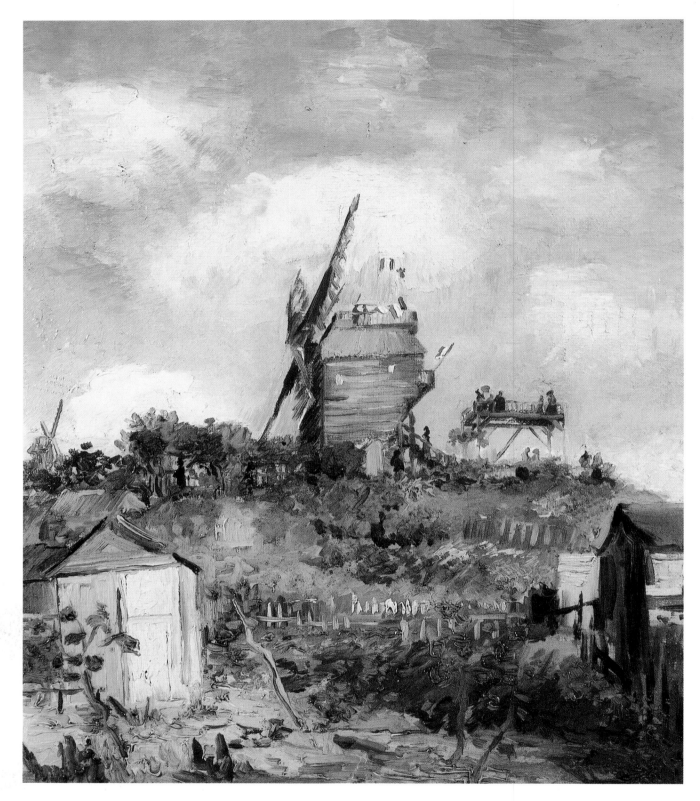

PLATE 7
Le Moulin de Blute Fin
Oil on canvas, 15 x 18¹/₈ inches (38 x 46cm)

PLATE 8
Le Moulin de la Galette (1886)
Oil on canvas, 15 x 18⅓ inches (38 x 46.5cm)

During the Impressionist period, the Moulin de la Galette was a favourite and lively haunt for painters of the group, the scene most famously depicted by Renoir in his painting of the same name. A number of windmills had been built on the hill of Montmartre (see also opposite), most of which were either destroyed or turned into bars, restaurants or dance halls by the mid 19th century. The translation of the name is 'windmill of the round cake' and evidently comes from its earlier practical life when it ground the basic ingredient of the special flat round cake known as a galette. When Van Gogh painted this view of the tavern from the rue Girardon, its heyday was already over and Van Gogh's painting perhaps reflects this decline in its sombre hues, still retained from his early painting. It is incidental evidence of the fact of Van Gogh's arrival in Paris when the Impressionist phase was giving way to the Post-Impressionist.

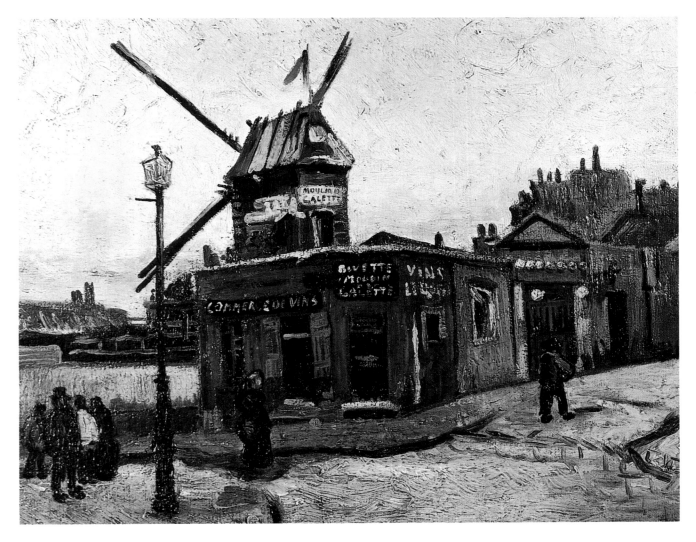

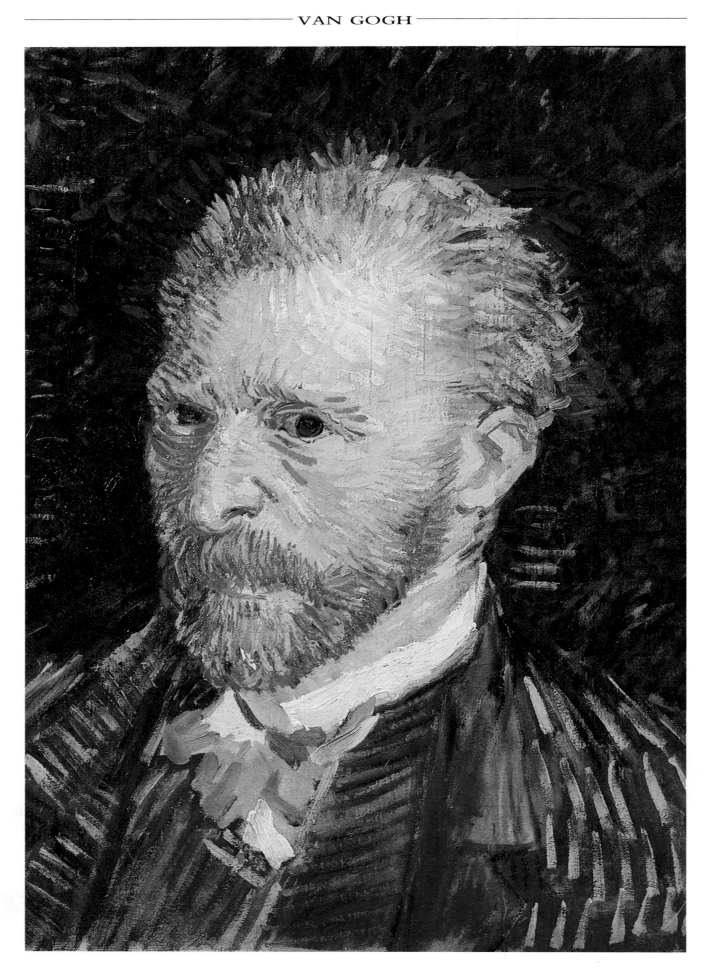

PLATE 9
Self-Portrait (1887) opposite
Oil on canvas, 17¹/₃ x 13³/₄ inches (44 x 35cm)

Van Gogh painted his own portrait a number of times between 1886 and his death in 1890 and almost all of them portray the same fiercely tormented spirit, aggressively regarding the world with a look of piercing intensity. This example from the Musée d'Orsay collection gives a good indication of the technique that he had adopted of short directional strokes and high key colour, opposed by dark. The unity of the work is obtained by the similarity of strokes in both high and low key areas. However, it is not the technique that is important and which distinguishes the work from true Impressionism, it is that the raison d'être is essentially the search for emotional identity that permeates all his self-portraits. Van Gogh is looking for a way of putting his own spirit – 'soul' he would have called it – in a tangible form. The technique and approach varied dramatically over the few years he was engaged in looking at himself.

PLATE 10
Wheatfield with a Lark (1887) below
Oil on canvas, 21¹/₄ x 25³/₄ inches (54 x 65.5cm)

When he painted this work, Van Gogh had begun to explore the pictorial possibilities of colour and texture inspired by his studies of old masters. His interest in the possible effects of paint itself, applied with passion, had been awakened and reaches its apogee in his last great paintings such as the Church at Auvers *(plate 43) and* Crows over a Wheatfield *(plate 54). He had also begun to realize the emotional content of colour. Although this work does not fully explore such matters, it does contain a vibrancy that was later developed. The single lark ascending – the solitary bird – is another reference to Van Gogh's sense of isolation.*

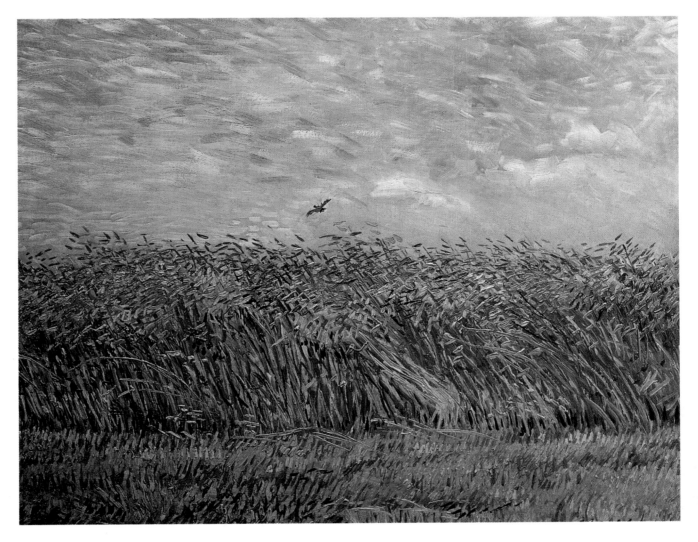

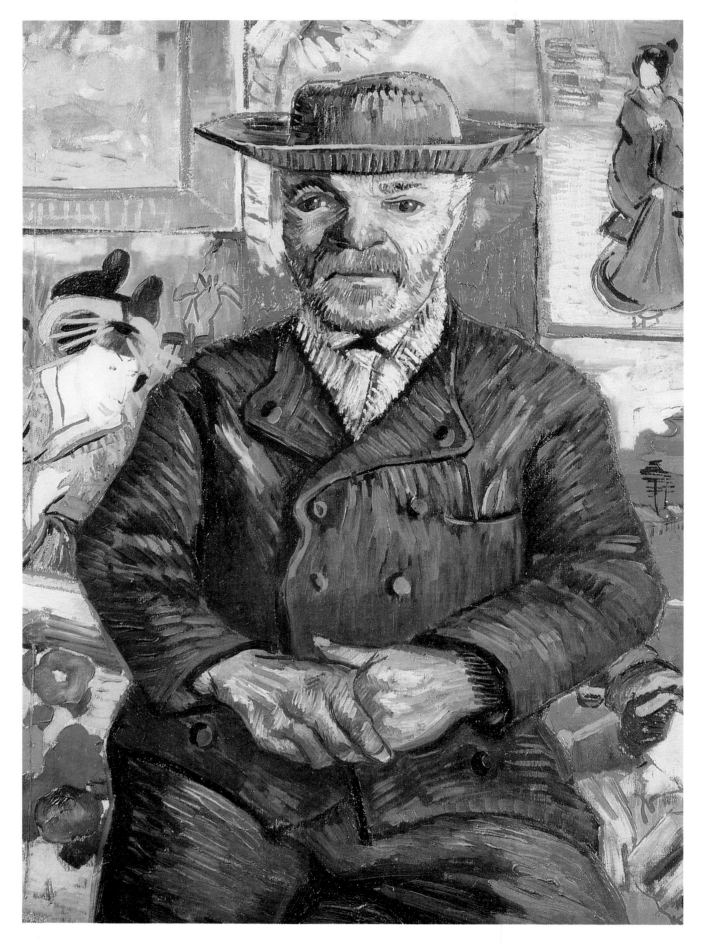

PLATE 11
Père Tanguy (Julien-François Tanguy)
1887–88
Oil on canvas, 25½ x 20 inches (65 x 51cm)

Père Tanguy was a colour merchant and art dealer who opened a shop in the rue Clauzel which became a meeting place for both Impressionists and Post-Impressionists. Some of these deposited their work with him and he became a popular figure in the

Parisian art scene. The most loyal of his clients were Cézanne and Van Gogh and it is said that Tanguy exchanged some of Van Gogh's paintings (he was unable to sell any of his work) for colour that he desperately needed. Van Gogh described Tanguy to his brother Theo as 'such a funny old soul, and I think of him many a time'. It will be noticed that the figure of Tanguy is surrounded by examples of Japanese art, further evidence of Van Gogh's interest in the style.

Continued from page 17

rudiments of preaching for laymen with the expectation that he would then take a post in a village, factory or mine and minister to the impoverished and unregarded peasants. Although Van Gogh was not considered a likely missionary, he was allowed to choose his own location for his ministry and he chose the mining community of the Borinage, nears Mons in Belgium, close to the French border.

At about this time he shared a room with someone who has left an interesting description of him. 'He was a singular man with a singular appearance as well. He was well built and had reddish hair that stood straight up from his head; his face was homely and full of freckles, but changed and brightened when he became enthusiastic – and that happened quite often... His attitudes and behaviour often provoked amusement because he acted, thought, felt and lived so differently from others of his age: he prayed for a long time at the table, ate like a hermit ... and invariably had a withdrawn, pensive, deeply serious, melancholy look on his face. But when he laughed he did so with such gusto and geniality that his whole face brightened.'

Typically, Vincent identified closely with his congregation, lived as they did, suffered the same privations, tended the sick, preached to them, and read the Bible to them whenever the opportunity arose and often

when it did not. These simple peasants were afraid and suspicious of this emotional zealot and he was soon dismissed by the mission's headquarters in Brussels. This was another devastating blow for which Vincent was totally unprepared. He had believed in his vocation and that he was providing a genuine service to the people of the mining community. This was a new blow to a person already full of insecurity – the knowledge that his religion was not enough.

At this time of stress Vincent began to question, not only himself, but his chosen profession. His letters to Theo, until this time filled with religious fervour, became appreciably less so. He remained in the Borinage and, while retaining his strong concern for the vicissitudes of peasant life, began to sketch the inhabitants and the landscape without training but with a passionate concern. His art, as with that of the Impressionists with whom he is usually associated, was never that of a dispassionate observer of the many facets of nature. It arose from a deep feeling for the human condition and the struggles inherent in life itself. The beginning of his transformation into an artist had its roots in the Borinage experience. He had always been interested in sketching and in art and had visited galleries in Holland, Paris, Antwerp and London. For a year he remained, wandering and sketching, at the end of which time, in 1880, he at last decided on his future – he would become an artist. He was 27, the same

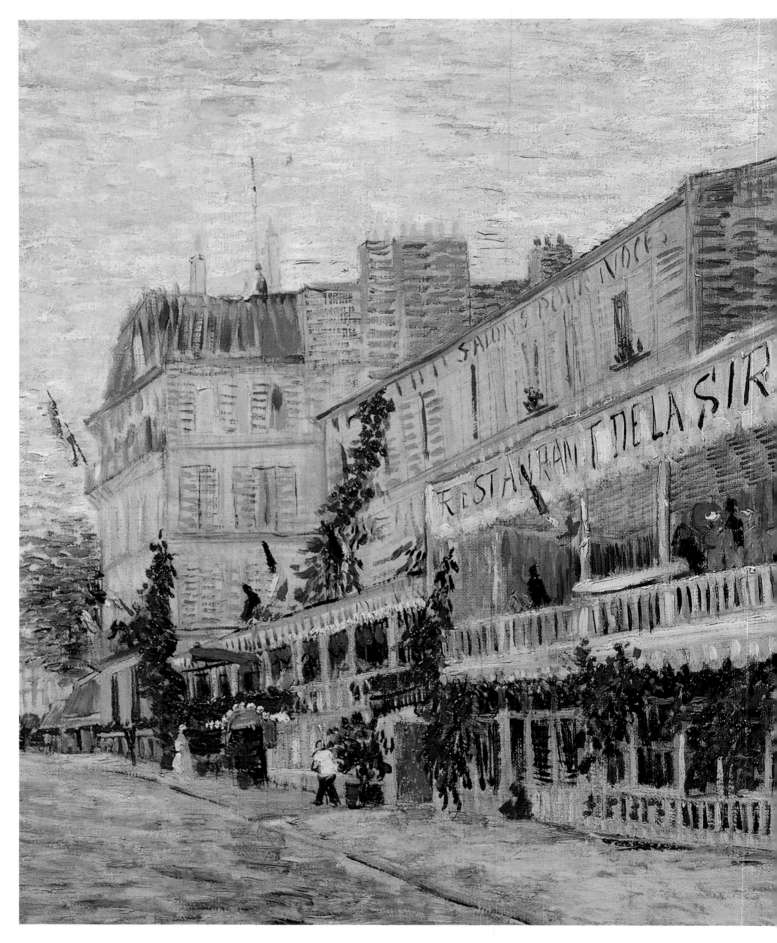

PLATE 12
The Restaurant of La Sirène at Asnières
(1887) detail

Oil on canvas, 21$\frac{1}{2}$ x 25$\frac{3}{4}$ inches (54.5 x 65.5cm)

This painting comes close to the spirit of Impressionism although it contains elements which are essentially Post-Impressionist and which represent the beginning of the change into Van Gogh's late style. There is a quality of lightness and fresh enthusiasm that suggests that he was in an optimistic mood, uncharacteristic of his usual depressive, unbalanced state. The attractive restaurant at Asnières, near Paris, was popular with painters and Van Gogh and Theo sometimes dined there.

age at which Masaccio had died.

Vincent returned to his family in Etten and thence to The Hague where he was encouraged by his cousin, the painter Anton Mauve, to study art. Theo, ever supportive and already providing his brother with an allowance, was sympathetic. After another unhappy liaison with a prostitute, Clasina Hoornik (Sien), who was pregnant, Van Gogh had to undergo treatment for venereal disease and after Sien had a second child in the following year, Theo succeeded in bringing the affair to an end. Van Gogh, deep in another trough of despair, returned to his parents, now back living in North Brabant at Nuenen, where he painted and drew the peasants in all their misery and heart-rending poverty. From the studies he made came his first notable masterpiece *The Potato Eaters* (1885), a dark, heavy and coarse painting infused with a deeply sympathetic if bleak atmosphere. (See plate 4.)

Vincent was by this time becoming interested in the technical and aesthetic elements of his profession. Delacroix's colour theory attracted him to stronger colour relationships and while still at Nuenen, the expressionistic possibilities of colour beyond its subject associations. 'Colour expresses something in itself, one cannot do without this, one must use it,' he wrote to Theo. His extending use of colour as a means of conveying symbolic associations rather than careful representation was associated with the increasing freedom with which he was

PLATE 13
Sunflowers (1887) detail
Oil on canvas, 17 x 24 inches (43 x 61cm)

*A subject close to his heart for symbolic reasons, Van Gogh
painted sunflowers many times, either lying on a table-top (as
here) or in a vase as in plate 24. The sunflower for him
represented nature and life, the power of the sun as a symbol
being for him almost as significant as it was for Turner who is
quoted as saying on his deathbed, 'The sun is God'. However,
Van Gogh, with his deep and abiding Christian faith, would
have reversed the message to 'God is in the sun'. The dominance
of yellow in these and other paintings, and its importance, is
reflected in the name of the house in which Van Gogh lived in
Arles – the Yellow House. In this example of sunflowers painted
in Paris before he left for Arles, the great size of the flower and
its ragged form gives it a sense of aggressive identity which almost
bursts from the picture, unlike usual flower paintings.*

PLATE 14
The Yellow Books (Parisian Novels) 1887
opposite
Oil on canvas, 28³/₄ x 36²/₃ inches (73 x 93cm)

*In France, the popular novels of the day were usually published
in yellow paper covers, as indeed many are today. They ranged
from cheap romances to the more serious works of literature. Van
Gogh was an avid reader and had a great admiration for such
writers a Balzac, Zola and Flaubert. This picture was painted
while he was living in the rue Lepic with Theo and one visitor
said that the interior was '...cluttered up with all sorts of furniture
and works of art. On the easel was the yellow picture called
Romans parisiens.' It is one of the earlier paintings in high
colour that Vincent began to produce during his first visit to Paris
and which presaged the familiar works of his last two dramatic
years.*

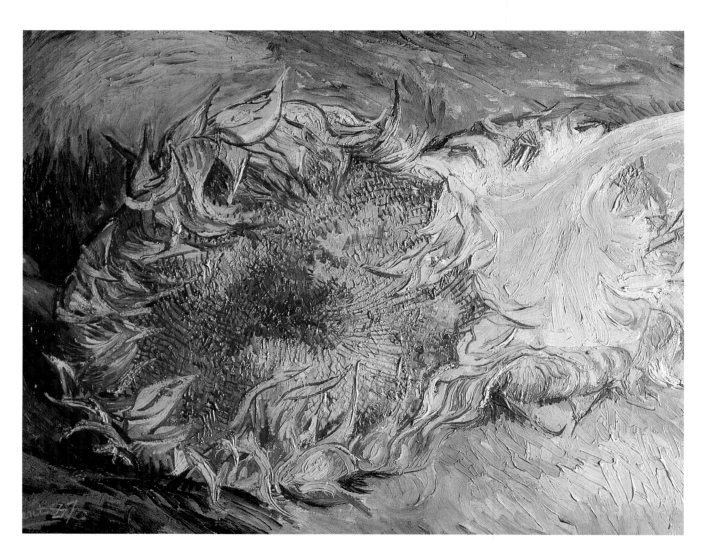

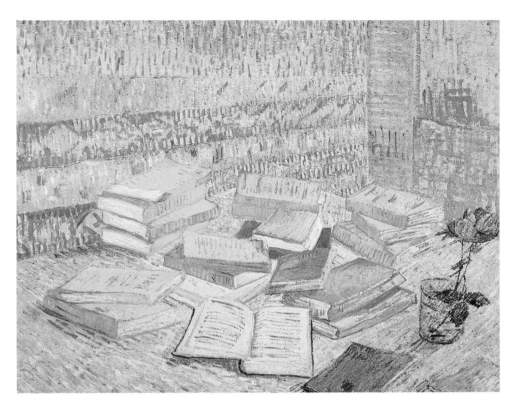

able to apply paint. His palette was changing from the harsh dark tones of the Nuenen paintings to a brighter, more vibrant colour range while his brushstrokes themselves carried a more passionate inner energy. This change marked Vincent's emergence as a painter with personal and individual views and an easily recognizable character. Subsequently, this became one of the factors in his posthumous success. And, of course, he had only about four years of life and work left to him.

He was beginning to recover his balance when, inevitably, things changed. He fell in love again with an older woman, Margo Begemann, who lived next door, but her family so disapproved of him that she was driven to attempt suicide for which he, characteristically but inaccurately, blamed himself. To add to his distress his father died suddenly in March 1885.

After a period in Antwerp where he encountered the rich colours of Rubens and the graphic strength of Japanese woodblock prints, Vincent went to stay with Theo in Paris where he worked for Goupil's successors, Boussod & Valadon at the Louvre. Theo was then living in the rue Laval (now rue Victor Massé) in which Degas later also lived, moving there in the year of Van Gogh's death in 1890. The influence of Rubens and the vitality of baroque art, particularly the religious subjects, was absorbed by Van Gogh and resulted in brushwork which is animated by the movement and tension in the art of the 17th century. But

Rembrandt, representing for him the strong Dutch ethic translated into a sympathetic luminous style, was also an influence which kept the Protestant in his nature alive.

In Paris, Van Gogh attended the studio of Cormon, who ran one of the well known ateliers where Toulouse-Lautrec, Louis Anquetin and Émile Bernard studied and where he met them. Through the paint dealer Père Tanguy, a friend of the Impressionists, he also made contact with the painters, most of whom had either achieved success or were on the verge of doing so. He was also introduced to Cézanne who by this time had moved artistically and technically away from the Impressionists and was following his own personal and fruitful pictorial direction, and to Gauguin who had abandoned his successful career as a stockbroker to become a professional painter. Most importantly for Van Gogh, he met Camille Pissarro and his son Lucien, and from Camille learned of the colour and pictorial theories of Seurat, practised by Pissarro and Signac whom he met in 1887, and variously called Divisionism, Pointillism and Neo-Impressionism. Included in the writings of Seurat were theories on the compositional structure of linear and tonal treatment. After Van Gogh's death Pissarro is reported as saying: 'Many times I have said that this man will either go mad or outpace us all. That he would do both I did not foresee.' Cézanne commented similarly, telling Van Gogh, 'Honestly, your painting is that of a madman.'

Van Gogh was already concerned, as has been noted

PLATE 15
Dance Hall at Arles (1888)
Oil on canvas, 25¹/₂ x 31⁷/₈ inches (65 x 81cm)

Painted during Gauguin's visit to Arles, this picture is not typical of Van Gogh's work and again shows the influence of his friend. (Despite the violent confrontations between them, they were nevertheless friends.) They visited the dance hall and the local brothels together but Van Gogh was temperamentally and morally ill at ease with this life. Examples of bars, cafés, dance halls and brothels appear frequently in the work of the Impressionists and in the work of Toulouse-Lautrec, who was virtually a resident in such places and presented them as happy milieux; but for Van Gogh this was not so and the overcrowded disorganized interior of his painting expresses this.

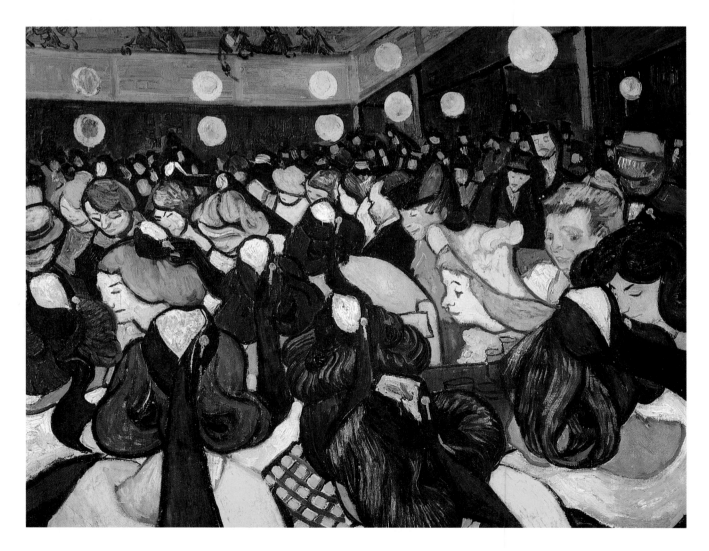

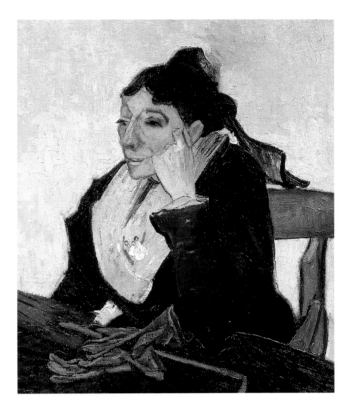

PLATE 16

L'Arlésienne: Portrait of Mme. Ginoux
(1888)

Oil on canvas, 36¼ x 28¾ inches (92 x 73cm)

Van Gogh painted Madame Ginoux a number of times, sometimes with only small variations. Madame Ginoux and her husband had befriended Vincent when he came to Arles in February 1888. This is one of two versions, almost the same size, the only difference (apart from actual brushstrokes) being the objects on the table. There is also an indication of what had become important to Van Gogh and many of his contemporaries — the influence of the Japanese print and evident in the sharp definition of form and the large blocked areas of colour.

above, with the expressionist values in colour and from the Neo-Impressionists learned of the theories of optical mixture. His attitude to colour application and intensity values was affected by these influential sources and in some paintings he adopted, if somewhat roughly, the divisionist technique of small dabs of complementary colours in close proximity. He was on a learning curve towards his last great painting stage. He was also much influenced, as were most of his contemporaries, by Japanese prints and bought many, organizing an exhibition of them at the café Le Tambourin.

Unable to sell his paintings, and frustrated by the lack of natural vistas in the city, he decided to leave Paris, but before leaving, and accompanied by Theo, made a visit to Seurat in his studio. In February Vincent, attracted to the warmth and light of the south, left for Arles. During the short period he had worked in Paris he had thus met most of his peers and become a recognizable figure among young Post-Impressionist painters.

On 20 February 1888, Van Gogh arrived in Arles, taking a room in an hotel and at the beginning of May renting four rooms as a studio in the 'Yellow House' in the Place Lamartine. At the same time, after an argument with the hotelier, he moved to other lodgings in the Place Lamartine run by Joseph and Marie Ginoux, whom he subsequently painted as *L'Arlésienne* (see above). He remained with them until September when he moved

from La Maison Jaune and was joined there by Gauguin in October 1888.

While in Paris he had planned a 'Studio of the South', which was to be a working centre for 'advanced artists'. It never materialized since the only artist he persuaded to join him there was Gauguin. From the beginning it was evident that their personalities would clash; violent quarrels ensued and Gauguin decided to leave. Van Gogh was more than devastated at the failure of his scheme and his reason broke under the strain; he never really recovered his mental balance again. After a quarrel in the local café on Christmas Eve, Gauguin was out walking, preparatory to his departure, when he turned to see Van Gogh about to attack him with an open cut-throat razor. Not at all intimidated, Gauguin faced him with contemptous disdain and after a few words Van Gogh ran back to his room, sliced off the lower part of his ear and took it to a brothel he frequented. An amusing report of the affair appeared in the local paper: 'Last Sunday at 11.30 at night one Vincent Vaugogh [sic] painter and native of Holland, presented himself at the *maison de tolérance* No 1, asked for one Rachel, and gave her ... his ear, saying, "Guard this object carefully" and then he disappeared... The unfortunate man was immediately admitted to the asylum.' Bleeding and distraught, Vincent was taken to the local hospital, Hôtel Dieu, where he was attended by Doctor Félix Rey.

Continued on page 35

PLATE 17
Promenade at Arles (Souvenir of the Garden at Etten) 1888
Oil on canvas, 28$\frac{1}{3}$ x 36$\frac{1}{4}$ inches (73 x 92cm)

Gauguin was an influence on Van Gogh, particularly after his visit to Arles and the unfortunate events that accompanied it. The influence was more inspirational than directly imitatory. Van Gogh interpreted a number of Gauguin's paintings in his own way and this work is an example. Gauguin's painting, Old Women of Arles, *probably painted during the two months that he spent with Van Gogh late in 1888, clearly influenced the* Promenade *work. There is a compositional relationship although the treatment is very different. Van Gogh uses a Neo-Impressionist effect of small strokes of colour and a tighter drawing. It is an unusual work not immediately and obviously by him.*

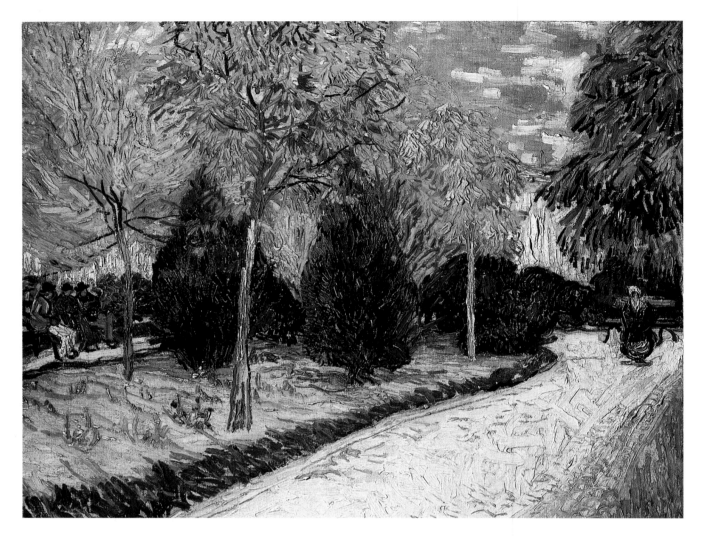

PLATE 18
Public Gardens at Arles (1888)
Oil on canvas, 28$\frac{1}{8}$ x 36$\frac{2}{3}$ inches (72 x 93cm)

This is an unusually gentle painting and reveals Van Gogh's enjoyment of his earlier period in Arles. In this work the usual lovers are replaced by a single figure on the extreme right. It is however in the foliage colours of great variety that Van Gogh's interest is focused.

PLATE 19
The Café Terrace on the Place du Forum, Arles, at Night (1888) detail opposite
Oil on canvas, 31$\frac{7}{8}$ x 25$\frac{3}{4}$ inches (81 x 65.5cm)

Van Gogh was always interested in light: the sun, moon, stars or as in this painting, an artificial source. He also stated that he was 'very interested in the idea of painting night scenes on the spot and actually by night', and described this work as 'the terrace of a café at night, lit up by a big gas lantern, with a patch of blue star-filled sky'. It was painted in the autumn after he had spent the previous month painting and drawing the sunlit fields of wheat around Arles. This was the café frequented by Van Gogh while Gauguin was with him and his influence is apparent in the strong warm colour of the café terrace.

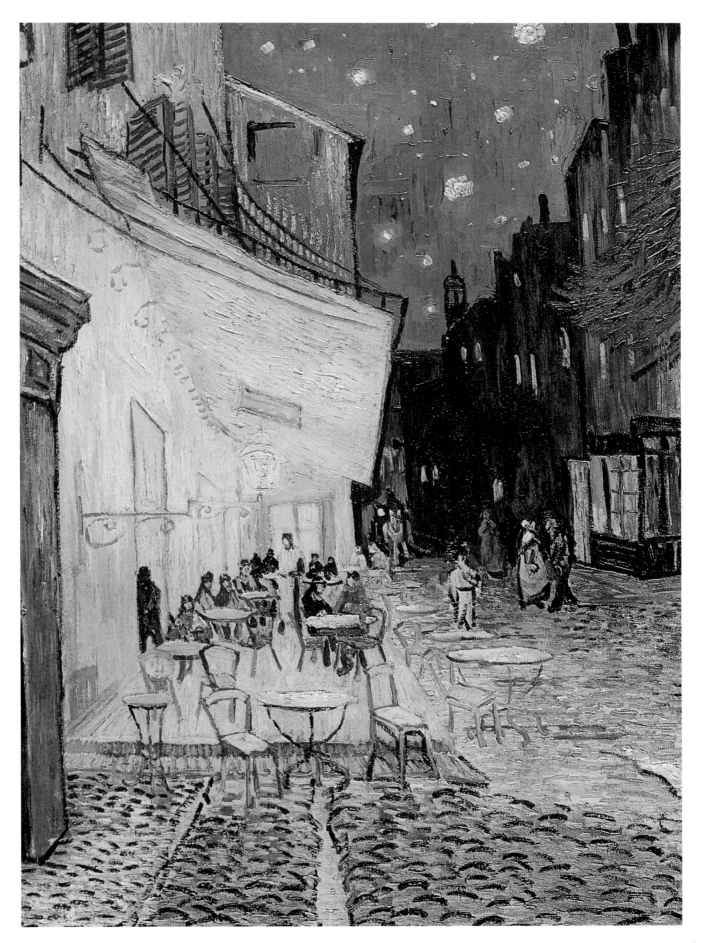

PLATE 20
Seascape at Les Saintes–Maries (1888)
Oil on canvas, 17¹/₃ x 20⁷/₈ inches (44 x 53cm)

In the summer of 1888, Van Gogh made a week's visit to Les Saintes-Maries, a small seaside village and site of a gipsy festival in the Camargue not far from Arles, and was enchanted by what he saw. While there, he did a number of paintings, including this view of brightly coloured fishing-boats on a breezy day. In a letter to his friend Émile Bernard, he wrote: 'On the flat, sandy beach were little green, red, blue boats, so beautiful in shape and colour that they made you think of flowers.' In another painting these boats are on the beach and it is clear that he saw in them a strong suggestion of a Japanese print and something of this is seen in the seascape. What is most evident here, however, is the importance he gives to the turbulent sea itself.

PLATE 21
The Lilac Bush (1888) opposite
Oil on canvas, 28¹/₃ x 36¹/₄ inches (72 x 92cm)

This controlled, observational painting, completed during a period of equilibrium in Van Gogh's life shows much of the mature technical quality that Van Gogh could achieve. There is little of the distortion or heightened emotional response of which he was capable at this time, as can be seen in his Sunflowers (plates 13 and 24). Irises, which Van Gogh grew to love, can be seen on the left side of the painting. (See also plate 36.)

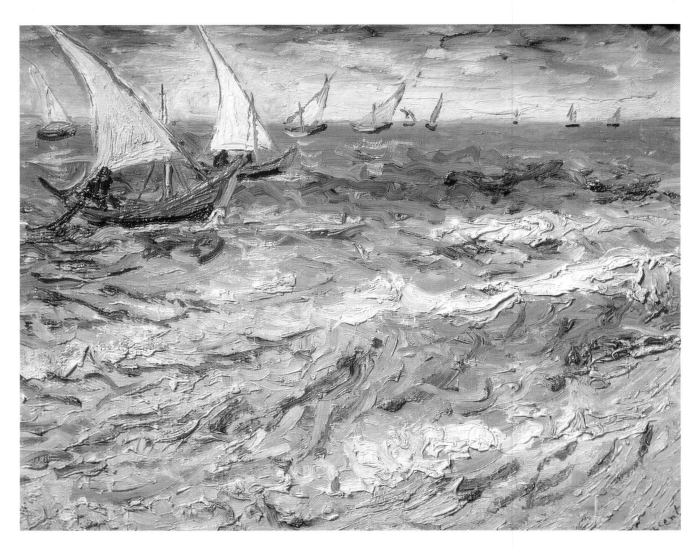

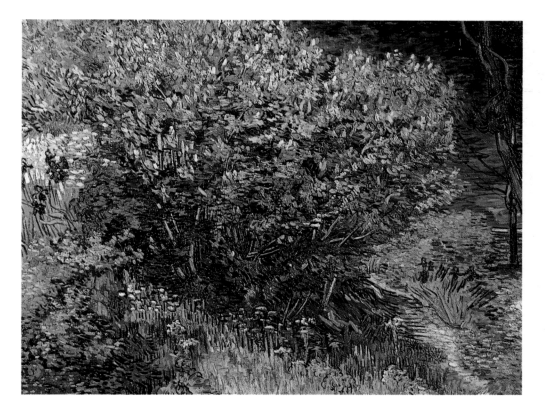

Continued from page 29

Gauguin left Arles, amazed and unwilling to have anything further to do with the 'mad Dutchman'; but before he left he telegraphed to Theo who arrived as soon as he could. He remained to take care of his brother and in a few weeks Vincent was well enough to leave hospital. The outlines of this story are perhaps the best known facts about Van Gogh and he himself provided evidence of its truth in his *Self-Portrait with a Bandaged Ear* of 1889.

The townspeople of Arles, fearing for their safety with this madman about, petitioned the mayor to have Vincent recommitted to hospital. Van Gogh himself realized that he had been seriously ill and that he had 'moments when I am twisted by enthusiasm or madness or prophesy, like a Greek oracle on the tripod'. Eventually he did recognize the real nature of his condition and admitted himself to an asylum for the insane, St.-Paul-de-Mausole, at St.-Rémy, arriving there in May 1889. The hospital doctor, Dr. Théophile Peyron, diagnosed him as suffering from epilepsy but having realized something of Vincent's genius, suggested to the asylum's doctor that he be given special attention and allowed to paint every day if he wished. Vincent was allowed to paint in the countryside around St.-Rémy and when the weather made painting out-of-doors impossible made copies of the masters, especially Delacroix, Rembrandt (his compatriot), and Millet – another painter of peasant life. He is known to have had a passion for cypress trees, their forms being highly responsive to the effects of weather, and it was while at St.-Rémy, late in his life, that this obsession began. This last phase saw a change in his style; darker and more emotionally expressive than the brilliant colour of his Arles paintings and commensurate with his mental condition. (See plates 28 and 49.)

It is part of Van Gogh's attraction that the real state of his emotional condition was expressed compulsively and effectively in his work. There have been few paintings more directly expressive of the emotion that inspired or perhaps necessitated them. It is difficult not to be moved by the anguish that was dragged across the canvas with every compulsive brushstroke. It is, however, important to recognize one characteristic of highly charged emotional events and their presentation in whatever form, and that is that the response inevitably diminishes in intensity with repetition. Even the most horrific scenes of war shown on television quickly become tolerable and we are eventually inured to them. The higher the original intensity the greater the degree of diminution. The impact of paintings, even such intensely disturbing examples as Goya's scenes of war and torture, cannot be of equal power after many viewings and this is true, too, of Van Gogh's work. What such images do however succeed in accomplishing is to leave an indelible identifying image – a recognizable icon. That is one of the reasons that Van Gogh has such

universal appeal – he can be instantly recognized. This, in turn, has another effect; he may be parodied, loved and become too familiar and all too easily taken for granted, his anguish and intensity diminished to the level of a birthday card.

On Theo's initiative, in May 1890, Vincent moved to Auvers-sur-Oise near Paris where he became a patient of Dr. Gachet, an amateur painter and a friend of Pissarro and Cézanne. Vincent's response to meeting Dr. Gachet is contained in a letter to Theo: 'I have seen Dr. Gachet, who gives me the impression of being rather eccentric, but his experience as a doctor must keep him balanced enough to combat the nervous trouble from which he certainly seems to be suffering at least as seriously as I.' Van Gogh, who really did believe the doctor was, as he later wrote to Theo, 'as ill and distraught as you or I', nevertheless became very close to him and with his encouragement began his last brief but happy period of intense work which ended with the painting *Crows over a Wheatfield* (plate 54).

Later on Sunday 27 July, when he had finished this deeply moving work, and in the fields where he had created it, Vincent shot himself in the chest with a revolver he had somehow managed to hide about himself. He died two days later and was buried in the cemetery at Auvers in 'a small new graveyard dotted with new headstones', as Émile Bernard described it. Theo was present, as well as Dr. Gachet, Père Tanguy, Lucien Pissarro and others. Theo, already in ill-health himself, collapsed and died six months later.

THE PLACE OF VAN GOGH IN ART

A survey of Van Gogh's short life reveals that his career in art was even shorter than might have been expected since his active artistic life was encompassed in the space of about six years of which only the last three produced those paintings which are characteristically his work and the object of such demand. One explanation of the high prices, to revert to the questions posed initially, is the rareness, the shortage of production models. Despite his

PLATE 22
Les Alyscamps, Arles (1888) opposite
Oil on canvas, 28³/₄ x 36¹/₄ inches (73 x 92cm)

While Gauguin was at Arles with Van Gogh they painted together, often choosing the same subject. One such, of which Van Gogh made four paintings, was an avenue of poplars which included a number of Roman stone sarcophagi lining the walk and used by the citizens as seats. The influence of Gauguin and his dominating personality is seen in most of these works where the colour is more intense than is usual with Van Gogh.

PLATE 23
Pollarded Willows with Setting Sun 1888)
below
Oil on canvas, 12³/₈ x 13¹/₂ inches (31.5 x 34.5cm)

For personal subjective reasons, artists frequently adopt natural phenomena as symbols of deep significance to them. Some, like the sun, are common subjects (one is reminded of Turner's supposed last words, 'The sun is God'), some essentially personal. For Van Gogh the sun was life and in its course represented life at sunrise and death at sunset. Trunks of trees were part of the life-struggle, cypresses in particular. It is therefore not surprising that Van Gogh, like others, returns frequently to his most affecting symbols.

In the year 1888, one of his most productive, his landscapes are full of the sense of natural energy and this vigorously painted work is a moving example of Van Gogh's internal tensions. The tree branches thrust upwards into the bright sky, almost seeming to obstruct the setting of the sun behind the resistant blue horizontal. The bright red spikes below the sun seem in contest with its rays.

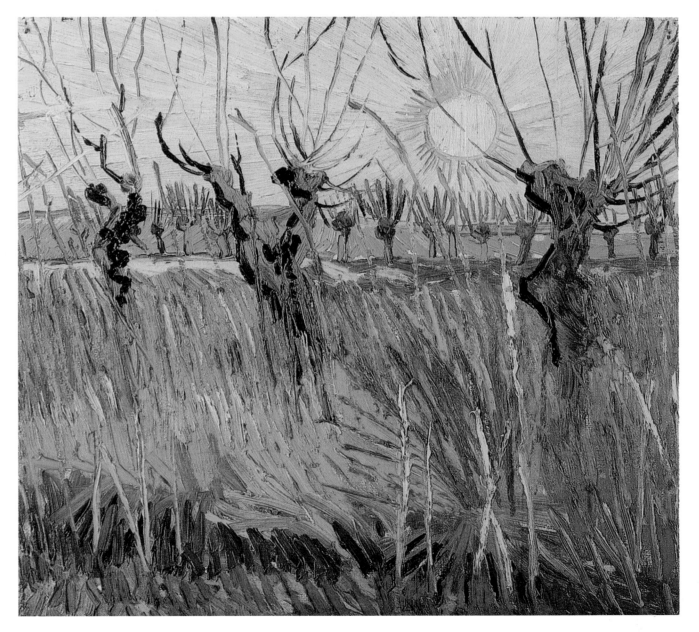

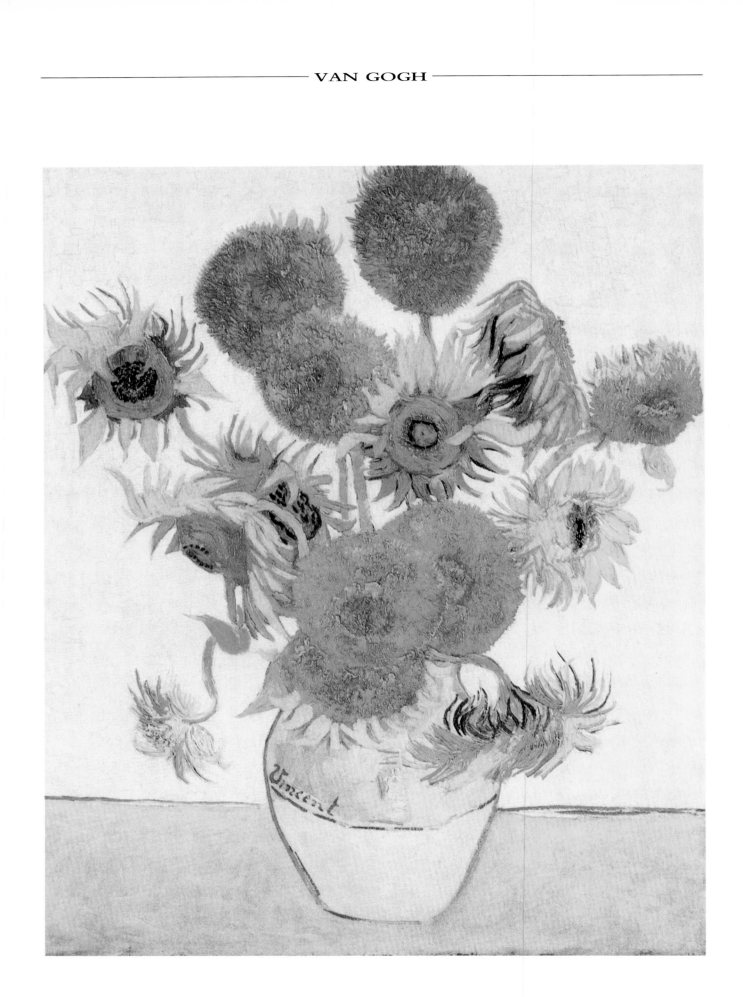

PLATE 24
Sunflowers (1888)

Oil on canvas, 36½ x 28¾ inches (92.5 x 73cm)

For the decoration of the room he occupied in Arles, Van Gogh painted a number of studies of sunflowers arranged in a vase with either a yellow or blue background. They are images of joy, of delight in the power of the sun, much stronger in Arles than in Paris, and the giant flowers seem almost to represent the sun itself in all its glory. It is from these paintings that a feeling of vital energy, almost intoxicating in its power (and that comes from most of his later paintings) begins to emerge. In one of Vincent's many letters to Theo after he had arrived in Arles, and describing his feeling of release from the culturally oppressive atmosphere of Paris, he wrote: 'I am painting with the gusto of a Marseillais eating bouillabaisse, which won't come as a surprise to you when you learn that I am painting sunflowers.' He was indeed frantically doing just that at the time since he wished to decorate the room with them in preparation for the arrival of Gauguin who was to join him in his ill-fated school, his 'Studio of the South'. While Gauguin was staying with him in Arles he painted Van Gogh working on his Sunflowers and when he saw the result Vincent's comment was 'It is certainly like me, but it is me gone mad.'

short working life, Van Gogh left over 2,000 paintings and drawings. It certainly has to be admitted that, forgeries or not, his work is easily and stylistically recognizable. A poor forgery in any highly individual style can often resemble an original and, with prices as high as they are, a successful forgery is bound to be highly profitable. And, again, since we know that Van Gogh repeated subject-matter, models are readily available without necessarily arousing suspicion.

None of this, however, answers the one question of real significance. What are the qualities to be found in Van Gogh's work that can have occasioned the commercial nonsense which is distorting and obscuring its real understanding and appreciation? And, again, how far is the veneration in which Van Gogh is now held responsible for establishing at least some of the criteria by which painting in general is judged? Other questions will reasonably be asked but the important matter to be established is the quality and achievement of a life that was tortured and tragic from almost beginning to end.

One or two observations may clear some ground. Firstly, Van Gogh was not an Impressionist. Even when he was associated for a brief time with Impressionist painters he was not painting Impressionist works. His interest in colour theory was directed towards different ends in his work. He never exhibited with the Impressionists, nor was he accepted by them. He is usually included in the Post-Impressionist movement and to the extent that his life and work was after Impressionism this is an accurate description; but as a way of discerning what the character of his work was it is no help at all. Cézanne and Seurat are also described as Post-Impressionists and no one familiar with their work and Van Gogh's would find it easy, if at all possible, to determine his style from an examination of Cézanne or Seurat – and vice versa. He is frequently linked with Gauguin as a Post-Impressionist and although there are certainly more temperamental similarities, quarrels apart, there is no great purpose in examining Gauguin in order to discover Van Gogh.

In describing Van Gogh as a Post-Impressionist and linking him with Cézanne, Seurat and Gauguin we do, however, indicate something of the character of the work that succeeded Impressionism. It is perhaps helpful to consider briefly the nature of Impressionism and its impact on 19th-century art. Before the Impressionists, most acceptable art was directed towards a cultural conservative élite of intellectuals, savants and the *haut monde*. It was an art displayed publicly in the annual Salon and was created by the academic painters and sculptors to confirm their superiority. The subjects they chose were derived from history, mythology or religion, usually from some obscure aspect of their subject which would emphasize the possession of esoteric knowledge of both the artist and his public. There was often a propagandist intention but,

Continued on page 43

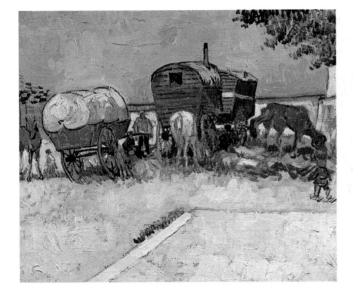

PLATE 25
Gipsy Encampment near Arles (1888)
Oil on canvas, 17³/₄ x 20 inches (45 x 51cm)

*As usual with subjects that interested him both visually and
emotionally, Van Gogh made a number of paintings of gipsy
camps. He was attracted, on the one hand, by the bright colours
of the gypsies' vehicles and clothes and at the same time saddened
by their isolation from society, a people apart. In this work he has
used the sky and foreground painted flatly (again influenced by
Japanese prints) to concentrate attention to action in the middle
band, thereby indicating both the psychological isolation and the
colourful cheerfulness of the gipsy camp. Two further points
should be made: the strong white form, not clearly identifiable,
thrusts the viewer visually into the scene and the subject is drawn
with careful and affectionate observation.*

PLATE 26
Starry Night over the Rhône (1888)
Oil on canvas, 28¹/₂ x 36¹/₄ inches (72.5 x 92cm)

*Fascination with stars – bright points of light in the velvet
dark – is recognized as a potential sign of a disturbed personality.
It is supposed to account for Ruskin's verbal attack on one of
Whistler's nocturnes. Van Gogh painted a number of nocturnal
works in the last two years of his life, some with swirling violent
forms suggesting meteors. In this painting, the coolness of
the haloed stars is contrasted with the warm lights on land
and their reflections in the water. Van Gogh was always in awe
of the vastness of God's heaven enfolding the earth. Although
not explicitly religious, his works often seem to have religious
implications.*

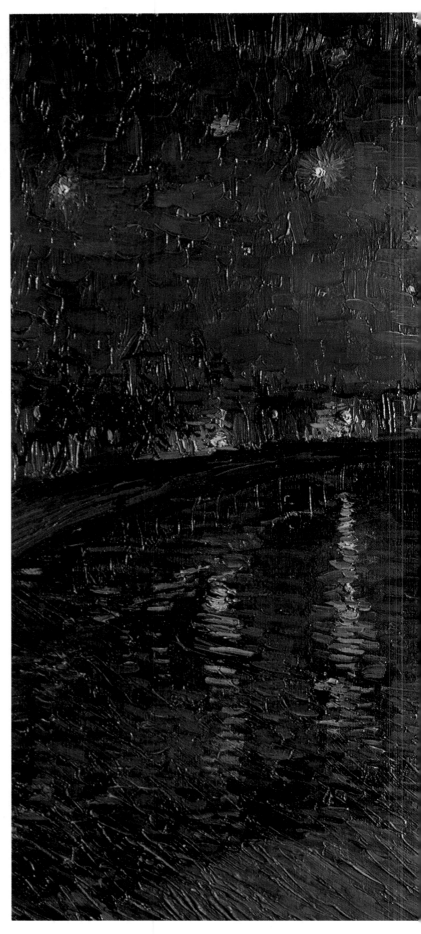

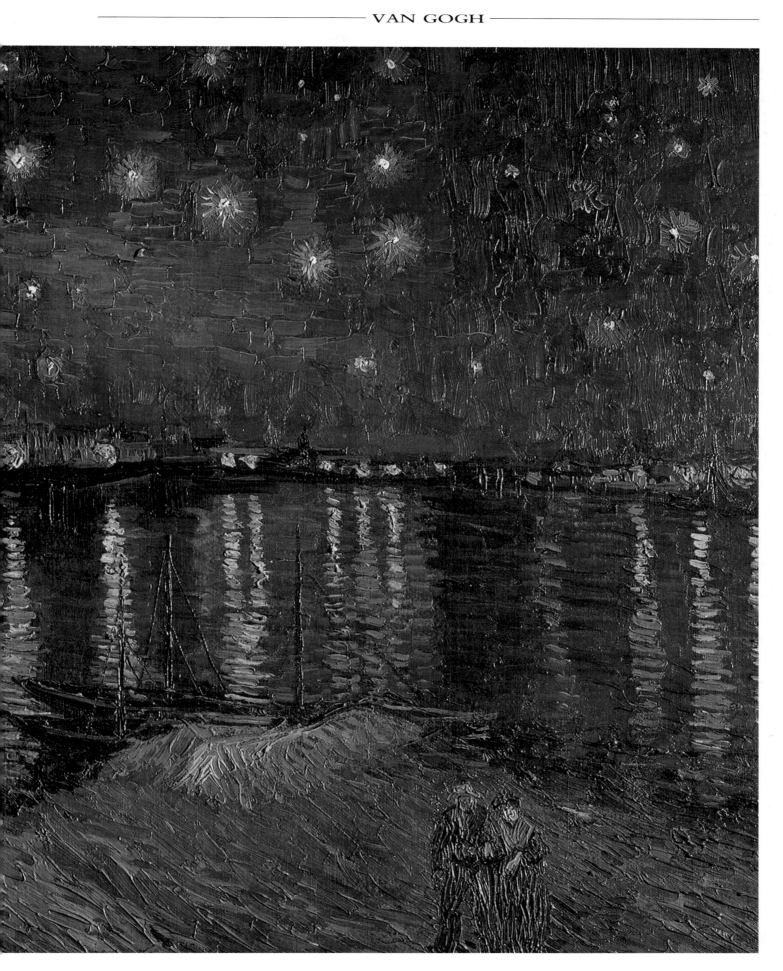

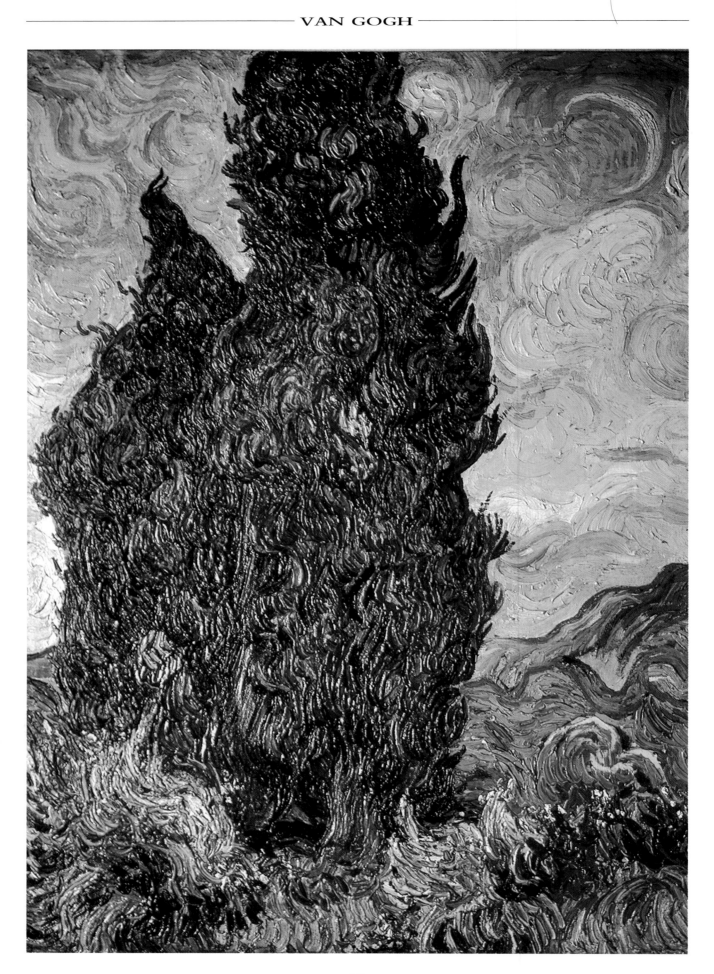

PLATE 27

Camille Roulin (1888–89)

Oil on canvas, 25 x 21¼ inches (63.5 x 54cm)

Camille Roulin was the son of Postman Roulin (plate 35). Van Gogh painted the members of the family a number of times and in different versions. Camille was the younger son and his elder brother Armand was a favourite subject whom he also painted a number of times. With Camille Van Gogh was not so enthusiastic and it has to be admitted, on the evidence of this painting, that he appears to have been a somewhat unattractive youth. Van Gogh wrote to his brother saying that he had painted a great many pictures of the Roulins in the hope of eventually acquiring some property – of course never realized.

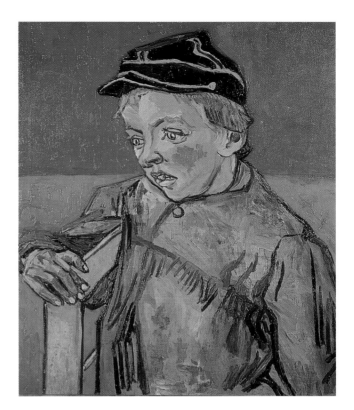

PLATE 28

Cypresses (1889) detail opposite

Oil on canvas, 36¾ x 29 inches (93.3 x 74cm)

The cypress tree has a special place in Van Gogh's work. Apart from the problems of painting it (see his comments in the note to plate 38), it represents in its form two elements in his make-up. It is solid and dense, sturdy and uncompromising – unlike the delicate, graceful forms of other trees. It seems to reach upwards in an attitude of supplication. Vincent saw the cypress as a bold, positive statement of the strength and permanence of nature. In a letter to a friend he declared: 'Landscapes with cypresses! Ah, it would not be easy ... and as for their appearance of flame – I think about it, but I don't dare go further ...' They became the visual equivalent of the emotional turmoil of his last year.

Continued from page 39

more usually, the purpose was to display the artists' technical and intellectual powers.

By the middle of the 19th century, this remote élitist art was beginning to inspire antagonism and dismay among the young art students who saw it as arid and irrelevant. They yearned for an art that had some connection with their own lives. In this atmosphere, a number of artists outside the academic world were already investigating the possibilities of a new art. They included Gustave Courbet, Eugène Boudin, Johan Jongkind and the Barbizon School which included Théodore Rousseau, François Millet, Jules Dupré, Jean-Baptiste Corot and Diaz de la Peña. These artists were all, in different ways, an influence on the young art students in the ateliers of the master artists of the day, some of whom would become members of the group known as the Impressionists.

In 1863, when Van Gogh was ten years old, the annual Salon in the Grand Salon of the Louvre was opened by the Emperor Napoleon III, who commanded that the works rejected by that year's committee of the Académie should be shown in other, unused rooms in the Louvre. His intention was to emphasize the superiority of the paintings in the Salon: but the idea backfired. Among the paintings in the Salon des Refusés, as it was called, was a painting by Édouard Manet, *Déjeuner sur l'herbe*, which caused such a scandal that the Refusés was never repeated.

PLATE 29
Doctor Félix Rey (1889)
Oil on canvas, 25¼ x 20⅞ inches (64 x 53cm)

Dr. Rey was the house surgeon in the hospital that treated Van Gogh during the ear-slicing episode. He was a man of sensitivity *and, as a result of Van Gogh's relatively long convalescence, they became friends. It was Rey who suggested that Van Gogh was anaemic and needed more food, and considered his emotional outburst to be a temporary thing. Van Gogh painted his portrait before he left, but Rey's appreciation was minimal since he subsequently used it to cover a hole in his chicken-house.*

The painting depicts two fashionably dressed men reclining on the grass in a park accompanied by a naked female who looks boldly and invitingly from the canvas at the viewers, while a second in the middle-distance is either dressing or undressing. The scandal was that it looked like a real scene, neither historical, mythological nor religious, and included a naked woman rather a classical nude.

The effect on the young painters was considerable and Manet became the leader, albeit reluctantly, of a new group that formed to discuss and implement the ideas of a new modern art. They eventually became the Impressionists and ten years later held their first exhibition (for a month from 15 May 1874) in Paris. The group, which included Monet, Degas, Renoir, Sisley and Cézanne, broke loose from the academic tradition, both in technical practice and subject-matter. Their subjects were the French landscape and ordinary people engaged in mundane pursuits. Their technical approach was to explore the effects of colour and light with a palette that generally excluded the use of black and encouraged a search for colour in shadow and light. It was essentially a surface art, visually varied and exciting, but neither intellectually pretentious nor emotionally demanding.

At this time Van Gogh, at the age of 21, was in love and working for Goupil's in London. He had not begun to paint although he had always been interested in sketching and drawing. In July 1874, he returned from London to his family and developed a deep and abiding interest in religion. Although he later met most of the Impressionists, as indicated earlier, he never exhibited in their subsequent seven shows, the last of which was held in 1886. By this time Van Gogh had started painting. (In the previous year he painted the first of his well known works, *The Potato Eaters*, plate 4.) His paintings were dark and sombre, more in the mood of Millet or Rembrandt than of the Impressionists.

Post-Impressionist painters, to the degree that they are different in kind from the Impressionists, pursue a different end. They are concerned, not with visual discoveries in pictorial terms as were the Impressionists, but with the expression of their responses to their subjects through feeling or analysis. Seurat, a colour and structure theorist, developed Pointillism, sometimes called Divisionism or Neo-Impressionism. Cézanne pursued a private odyssey towards obtaining a unified structural relationship between subject and painting. Gauguin looked for a romantic interpretation of the possibilities he saw inherent in the new Impressionist palette. Van Gogh, as we have already seen, used the new colour opportunity to produce an art of intense emotion. These figures were the four leaders in France of Post-Impressionism as interpreted in terms of pictorial development; Seurat and Cézanne towards an intellectual order, Gauguin and Van Gogh towards passionate emotional involvement. These two last are

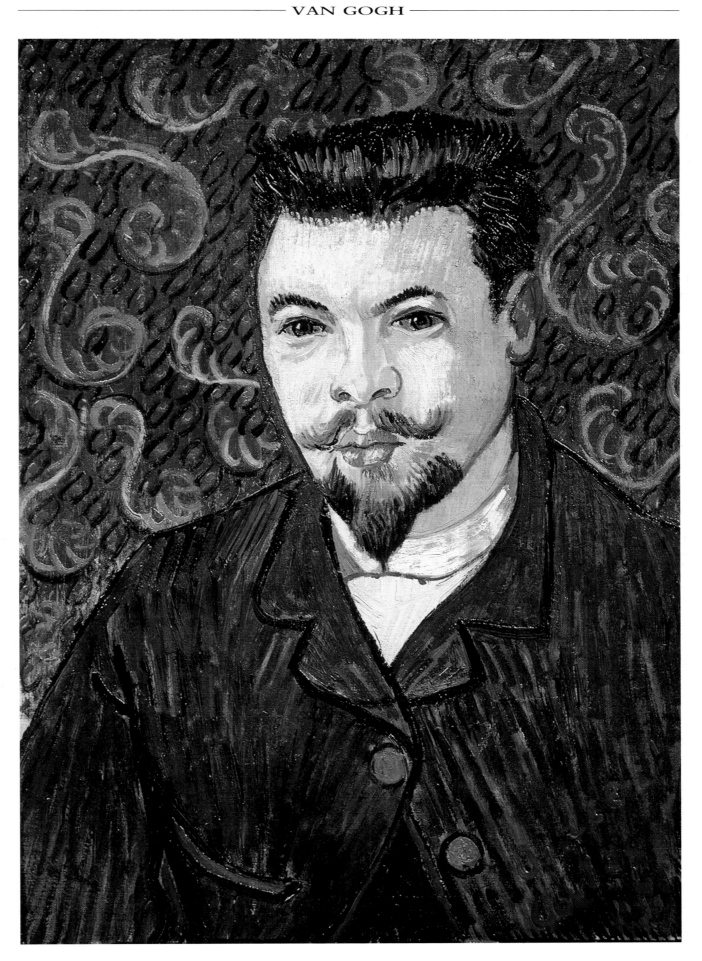

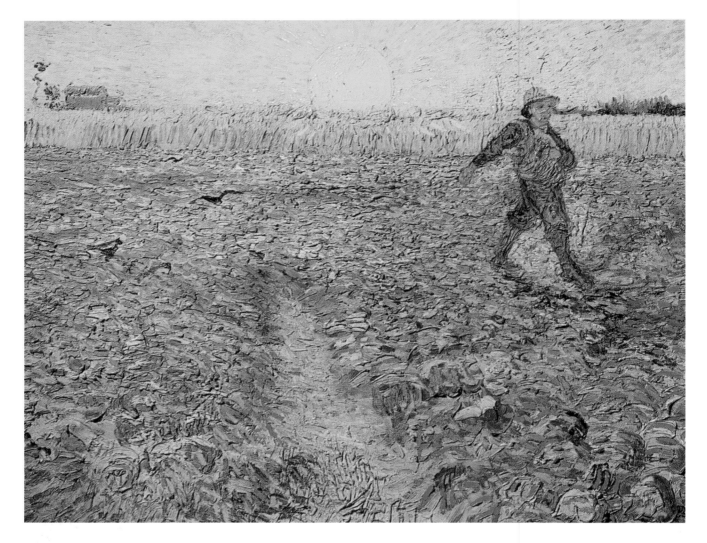

considered to be the principal inspiration of what in this century has become known as Expressionism. Van Gogh was the only one of these now highly regarded artists not to have received public recognition in his lifetime, although he was beginning to be recognized by his painter contemporaries and some art critics.

Every creative artist to some extent lives before his time, opening a door to a new vision, and Van Gogh was no exception. Individuality is part of being human, but only the driven artist, driven, that is, by what Wassily Kandinsky called the 'inner necessity' to externalize his feelings or thoughts, exposes himself to public examination. This may offer a number of different responses for the artist, from pride to despair. For Van Gogh, especially in his last intense paintings, it appears to have been a deep and pathetic yearning to identify with nature in which life is a struggle against death; the canvas carries a reality which is not the subject but physically carries, as the painting may be carried, the actual emotion

trapped within the brushstrokes themselves. Not one dab of paint is casual; for Van Gogh such an action would have been unthinkable. This is also true of Cézanne but in his case the brushstrokes are different in character and their application reflects, not that of the emotionally-driven Van Gogh, but the careful search for the 'harmony' of the whole.

Intense pain, intense passion and unstable temperament do not inevitably produce the results that we see in Van Gogh's work and it is important to recognize that it is not only or even commonly true that intensity or instability in themselves produce valuable or valued results. Other factors are essential and it is here that Van Gogh's qualities are really to be discerned. He fought to transcend his destructive, demoralizing tendencies in order to create a concrete expression of the natural order. To do this, he had to retain part and reject part of his essential nature; he had to learn a language of expression that could be given form in painting. It is his triumph that he succeeded.

PLATE 30
Sower with Setting Sun (After Millet) 1888
opposite
Oil on canvas, 25¼ x 31⅔ inches (64 x 80.5cm)

PLATE 31
The Drawbridge Across the River at Arles with Washerwomen (1888) below
Oil on canvas, 21¼ x 25½ inches (54 x 65cm)

The simple dignity and compositional power of Jean-François Millet's (1814-75) paintings had always been a potent influence on Van Gogh and he made many paintings, some direct copies, some following Millet's subjects and this example, although not a direct copy, has a painting by Millet as a model. The devotion to Millet is evident in the fact that from the spring of 1890 Van Gogh made no fewer than 23 paintings after Millet. He believed that he was 'improving' on Millet in at least one respect. Writing to his brother, he stated that Theo would be amazed how effective Millet's Field Workers *becomes 'through use of colour'. This is apparent in* Midday *(plate 42).*

One much-favoured subject while Van Gogh was in Arles was painted a number of times, usually from this vantage point, and he observed the different activities that occurred near it. In this painting he shows washerwomen using the fresh water of the stream while the drawbridge is down to enable a carriage to cross. The simple structure is clearly drawn and the colour is typically bright and positive. The scene is presented in a much calmer spirit than would overtake Van Gogh at the end of the year.

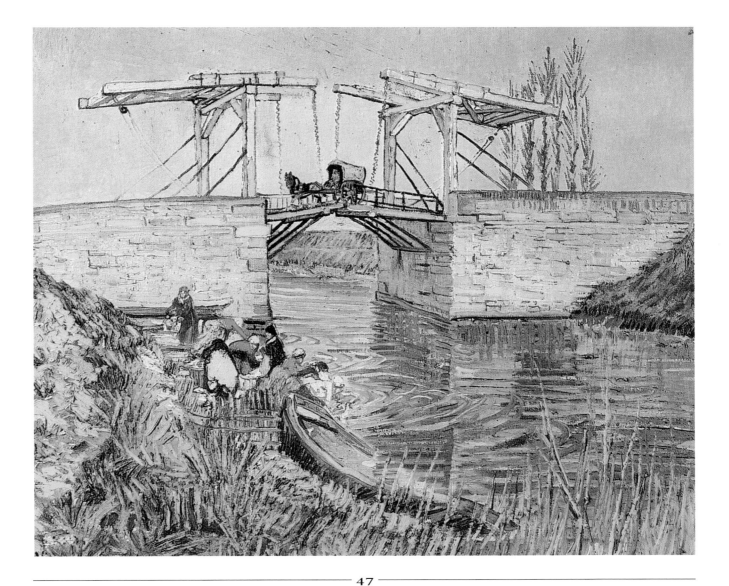

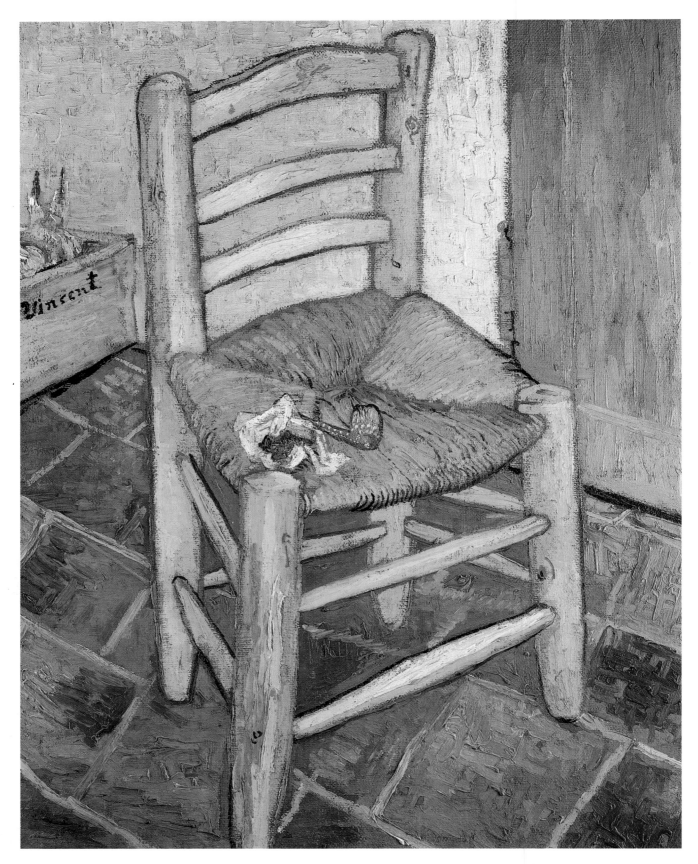

PLATE 32
Van Gogh's Chair with His Pipe (1888)
Oil on canvas, 36²/₃ x 29 inches (93 x 73.5cm)

This famous chair can also be seen in the view of Van Gogh's bedroom below. The painting raises a number of questions about the nature of art and perception which cannot be elaborated here but Aldous Huxley in Doors of Perception *makes a very interesting point in reference to this work. Under the influence of mescalin he says that the intensity of identity in simple objects was revealed to him when on return to normality he immediately saw a print of Van Gogh's chair and realized that it was an expression of just such a perception.*

PLATE 33
Van Gogh's Room at Arles (1889)
Oil on canvas, 28³/₄ x 35³/₄ inches (73 x 91cm)

This is the bedroom in the Yellow House that Van Gogh had rented from a hotel proprietor in the town. In a description of the room published in a review of his work after his death, the author notes that the painting '... depicts the room that he rented. The bedstead is orange, the chairs are golden yellow, the wallpaper is bright blue, the chimney purple, the table green and the floor brick red. One must have something in order to use such colours and to produce with them something good, something harmonious.' Van Gogh painted a number of versions of his room, with very little variations apart from the colour scheme.

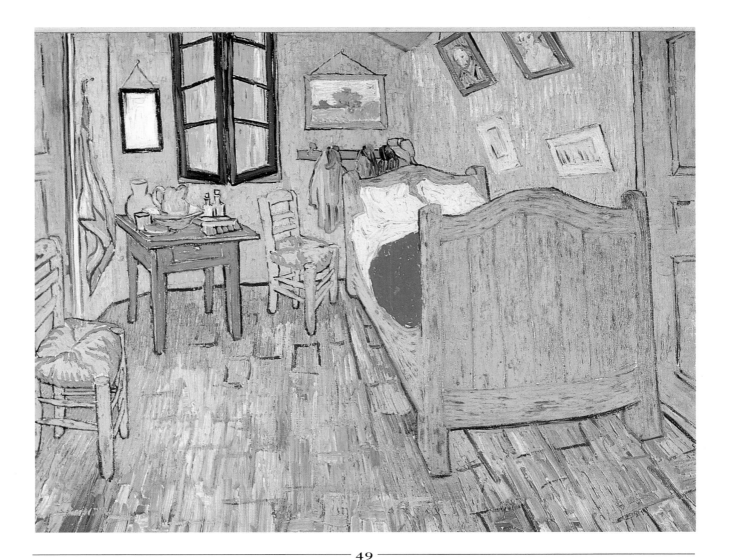

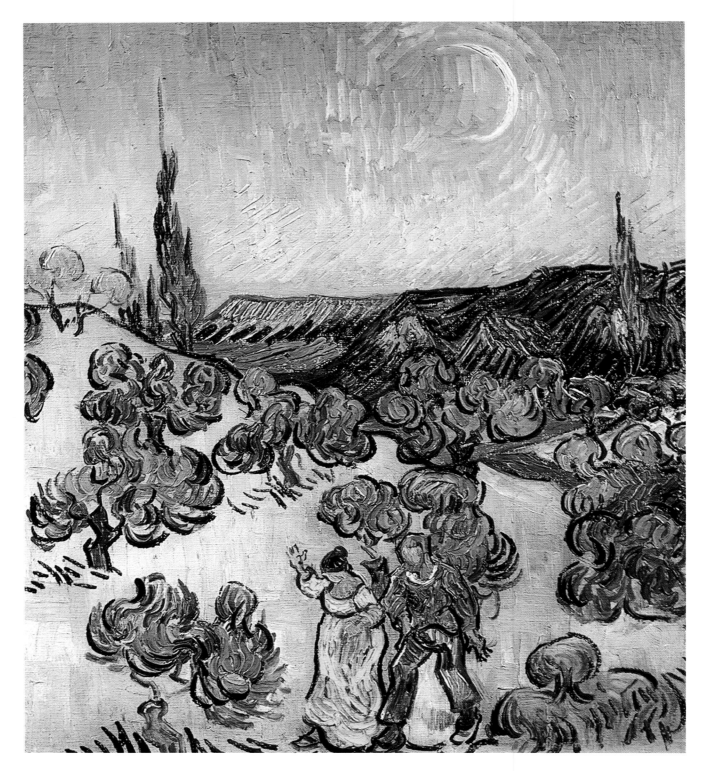

PLATE 34
The Evening Walk (1889)
Oil on canvas, 19$\frac{1}{2}$ x 18 inches (49.5 x 45.5cm)

In this year Van Gogh began the process of mental collapse which led to his suicide in the following year. The beginning of absence of control and mental instability can be discerned in this moving painting. The forms of the trees are mere linear expressions of struggle and the dark form of the landscape overhangs the two figures seemingly engaged in violent discussion. All is flux although perhaps not despair. Vincent's deterioration was not an interrupted progress and paintings done in 1889, such as Postman Roulin opposite, establish this.

PLATE 35
The Postman Roulin (1889)
Oil on canvas, 26¹/₂ x 22 inches (67.5 x 56cm)

*While in Arles, Van Gogh made many portraits of the local
inhabitants, with some (as with Roulin) in a number of versions.
Many of his sitters, in their simple rural life, had not encountered
artists before and were nervous of being painted, especially by a
man as uncompromising and demanding as Van Gogh. Not
surprisingly, they often look either apprehensive, aggressive or very
self-conscious, characteristics which Van Gogh captured, describing
Roulin in a letter to a friend as '...a Socratic type no less Socratic
for being something of an alcoholic with a consequently high
colour... He is an awful old Republican like Père Tanguy.'*

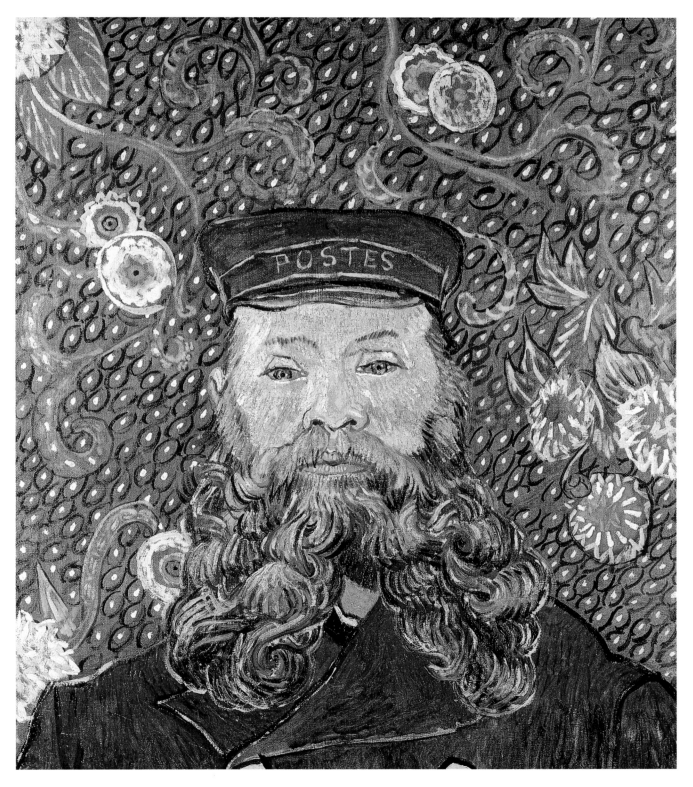

PLATE 36
Irises (1889) below
Oil on canvas, 28 x 36²/₃ inches (71 x 93cm)

The iris had a particular attraction for Van Gogh who enjoyed painting most flowers. In each case, whether his subject was a portrait or a natural growing form, Van Gogh struggled to uncover and express the inner identity as he saw it of each special element of nature. For many painters, the external visual perception of such a subject would be their principle consideration. For Van Gogh, this was much less important than the nature and growing life that it manifested.

PLATE 37
The Harvest (c.1889) opposite
Oil on canvas, 28³/₄ x 21¹/₄ inches (73 x 54cm)

This view across the fields towards the town of Arles, effectively concentrates the eye, in much the same way as in Gipsy Encampment *(plate 25) by leaving an open foreground, quietly painted, and a clear sky above the action placed a little above the middle. The harvesters and the wheat stack are linked to the town, one dependent on the other. Cutting across the link is a frequently used (by Impressionists) symbol of progress, a rail train, its blue smoke beginning to obscure the town. It is the conjunction of what might be thought to be fortuitous relationships that have a real significance for Van Gogh and for his statement. (See also plate 47.)*

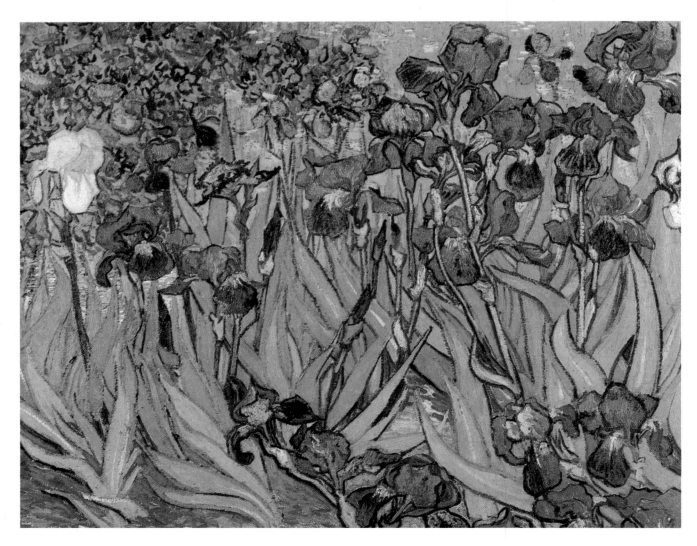

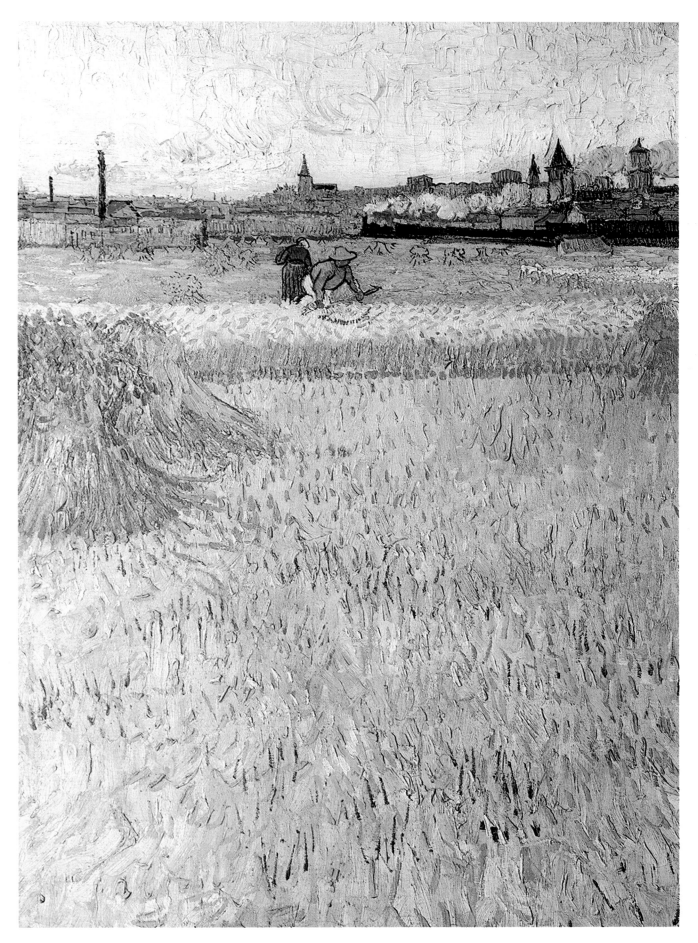

PLATE 38
The Green Wheatfield with Cypress (1889)
detail
Oil on canvas, 29 x 36³/₈ inches (73.5 x 92.5cm)

In Auvers, during the summer of 1889, Van Gogh painted
many open-air subjects in the strong sunlight. The idea of the
growing corn, the sun and the harvest was for him an expression
in palpable terms of God's purpose and involvement with
mankind. He treated the subject in a great variety of ways from
open landscapes to close-ups of corn stacks. This painting shows
the wheat ripening in a rich landscape. Centrally, in the
background, there is a cypress tree which was yet another passion
of Van Gogh's. He wrote to Theo at this time that cypresses were
always in his thoughts: 'It astonishes me that they have not yet
been done as I see them … a splash of black in a sunny
landscape.'

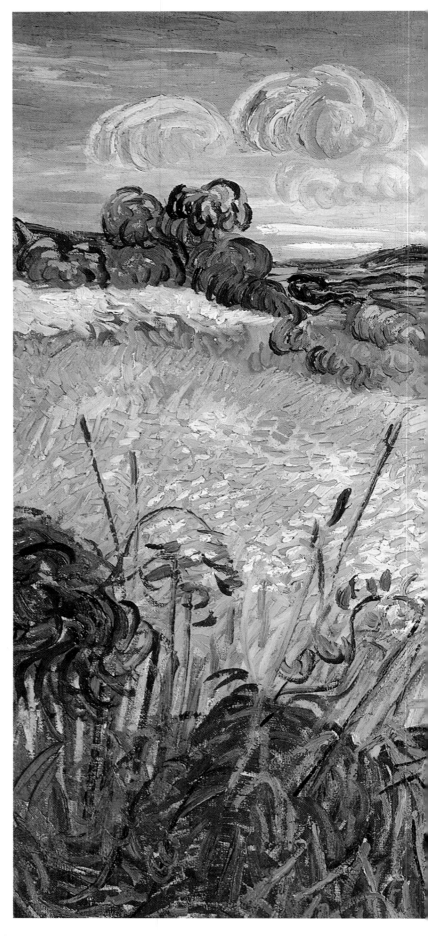

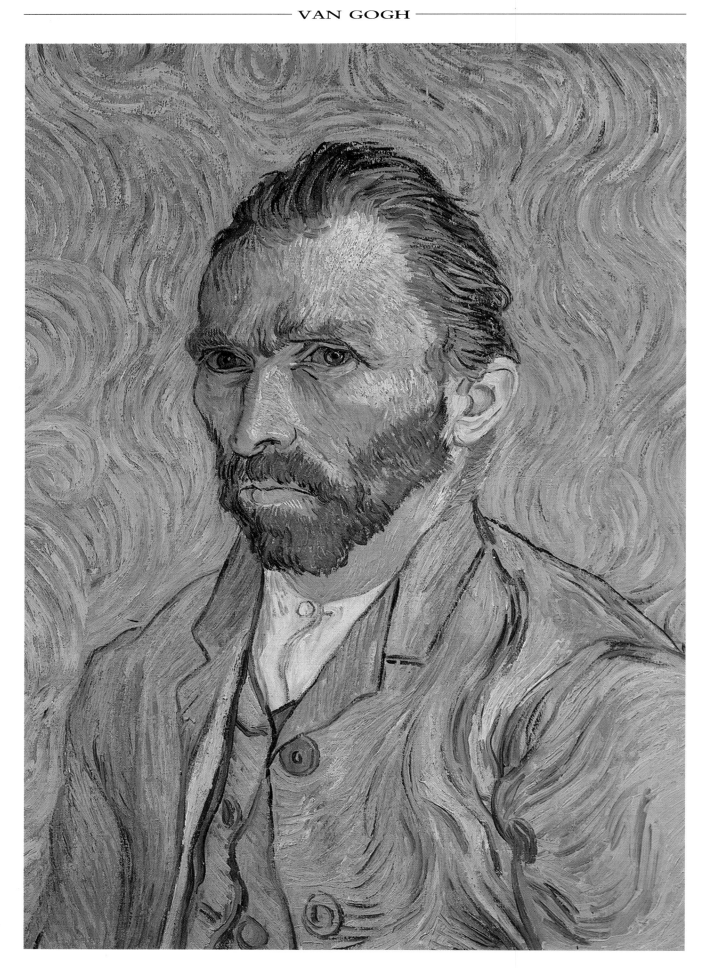

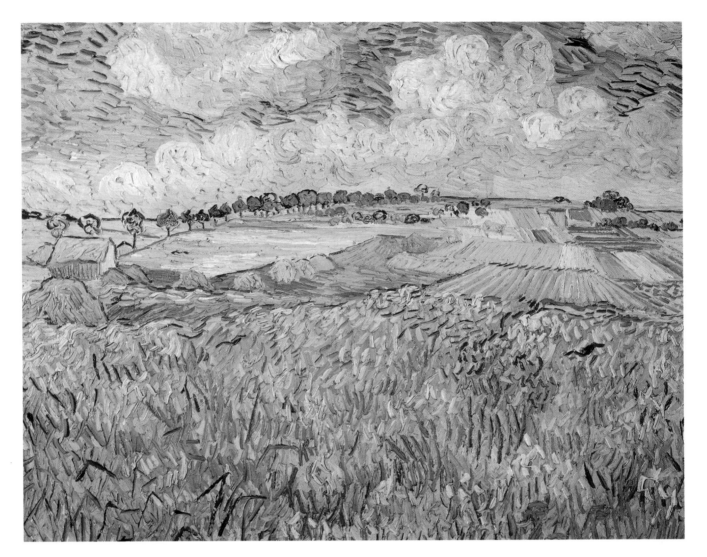

PLATE 39
Self-Portrait (1889)
Oil on canvas, 25$^1/_2$ x 21$^1/_4$ inches (65 x 54cm)

Of the many self-portraits that Van Gogh painted, this is one of the more revealing of his state of mind. Painted in Auvers less than a year before his suicide, the stern quizzical gaze, the tight-lipped reserve and the cool positive modelling and colour indicate that he is not at peace with himself or the world. But even more revealing is the background – an indeterminate swirling mass, giving almost a feeling of cold fire. It is Van Gogh's control of the drawing of both the head and the background that is perhaps the most disturbing element in the painting. He is near to bursting; to becoming part of the maelstrom.

PLATE 40
Landscape near Auvers (1889)
Oil on canvas, 29 x 36$^1/_4$ inches (73.5 x 92cm)

Van Gogh spent much of his time while living in Auvers in painting the countryside around the town. This is a controlled example of the open fields, planted with corn or vegetable crops with a fallow patch in the foreground with, somewhat unexpectedly, three bright red flowers in the lower right corner. The clouds are high and light and the whole effect is one of peace. Life was not always stressful for Van Gogh and many of his paintings are of this kind.

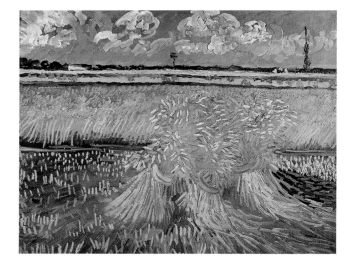

PLATE 41
Wheatfield with Stacks (c.1889) above
Oil on canvas, 21³/₄ x 26¹/₄ inches (55.2 x 66.6cm)

The horizontal banding in this painting is a recognized method of
introducing a sense of space and calm. It offers a balancing
programme and it is interesting to see how consciously Van Gogh
has contrived this. The skyline is the key. In the centre, the form
of the tree makes the fulcrum and the two buildings to left and
right, each the same distance from the side, are the objects being
weighed. The slender tree on the right in a clear sky is weighed
against the more tonally differentiated clouds on the left. Thus,
the whole upper area is in calm and balance. The only thing that
disturbs this balance is the group of stacks which suggest the
interference of man in a balanced nature – a familiar theme of
Van Gogh's.

PLATE 42
Midday (after Jean–François Millet) 1888–90
Oil on canvas, 28³/₄ x 35³/₄ inches (73 x 91cm)

Van Gogh had much in common with the painter Millet, whose
painting The Angelus, *with peasants standing silently in prayer*
in the fields, is one of the best known images in 19th-century art.
Millet lived and worked among peasants, indeed was himself a
peasant, and depicted the life of his village in its many aspects.
Van Gogh made copies of many of Millet's drawings and
paintings, not precisely but catching the substance. One of these is
Midday *which Millet produced in painting and etching. Van*
Gogh's version is accurate in content, from the side-by-side
billhooks and shoes to the cart and cattle in the distance. The
great difference is Van Gogh's colour intensity against the tonal
construction of Millet.

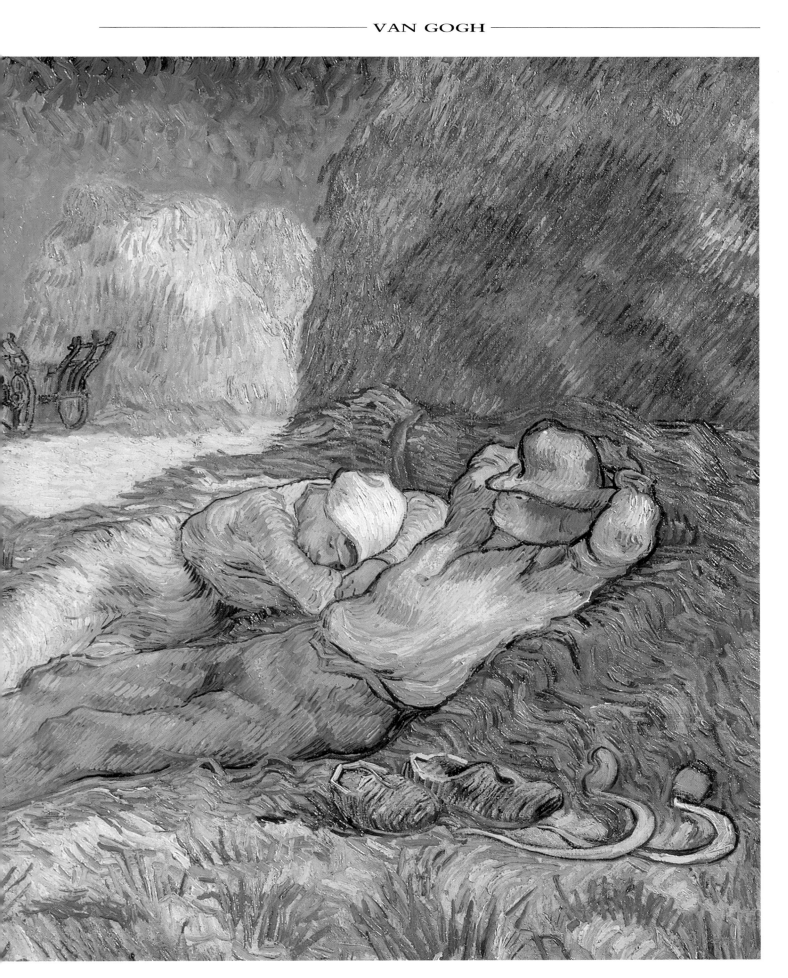

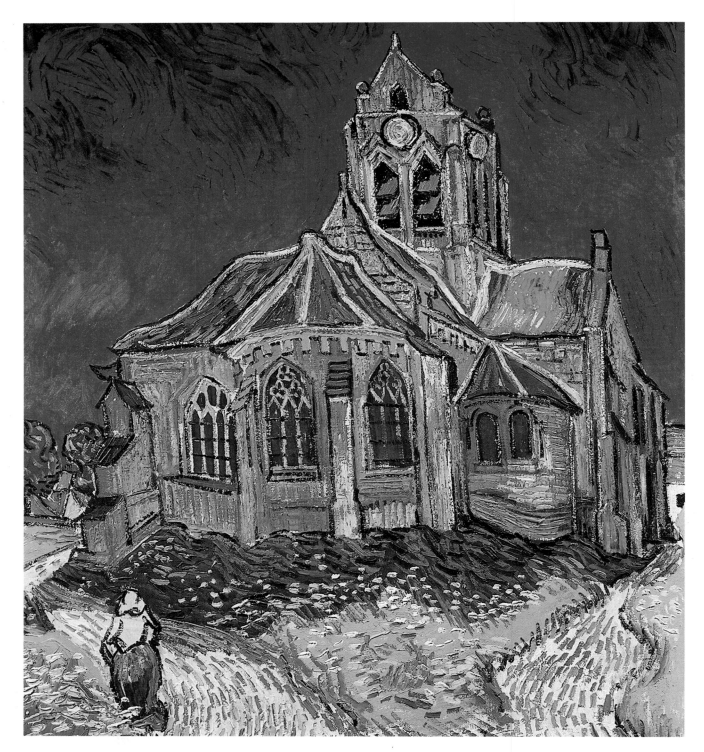

PLATE 43

The Church at Auvers (1890)

Oil on canvas, 37 x 29 inches (94 x 74cm)

Although this is one of Vincent's last paintings at Auvers, it is also one of his most intriguing. It is an indication of his state of mind in the last months and much may be read into it. The building itself seems to be writhing on its foundations and despite his almost fanatical religious faith suggests that Vincent is struggling within himself. The contrast of deep dark sky, the strong sunlight and clear-cast shadow indicates a soul in conflict which is again indicated by the division of the path surrounding the church to the left and right; a divided tortured mind, isolated within itself as shown by the single, strongly-drawn figure. Van Gogh's own view of the painting is, of course, less analytical in the description he gave Theo: 'The building is violet against a sky of simple deep blue, pure cobalt, the stained glass windows appear as ultramarine blotches and the roof is violet and partly orange.'

PLATE 44
Roses and Anemones (1890)
Oil on canvas, 20 x 20½ inches (51 x 52cm)

Early in his studies, Van Gogh made a number of still-life paintings, including a pair of old boots. They were all done for the same purpose – to develop a technique and to learn about form, volume and colour. Many of them have become famous *because of their unusual subject-matter and treatment. But Van Gogh also made a number of paintings of very common subjects, including flowers in vases. The most well known are his Sunflowers (plates 13 and 24), but throughout his later work he made flower paintings no longer as studies but as mature expressions of his intention. In this painting, the angular shape of the table-top and the vase are submerged by the vitality of the flowers, while at the same time heightening their character.*

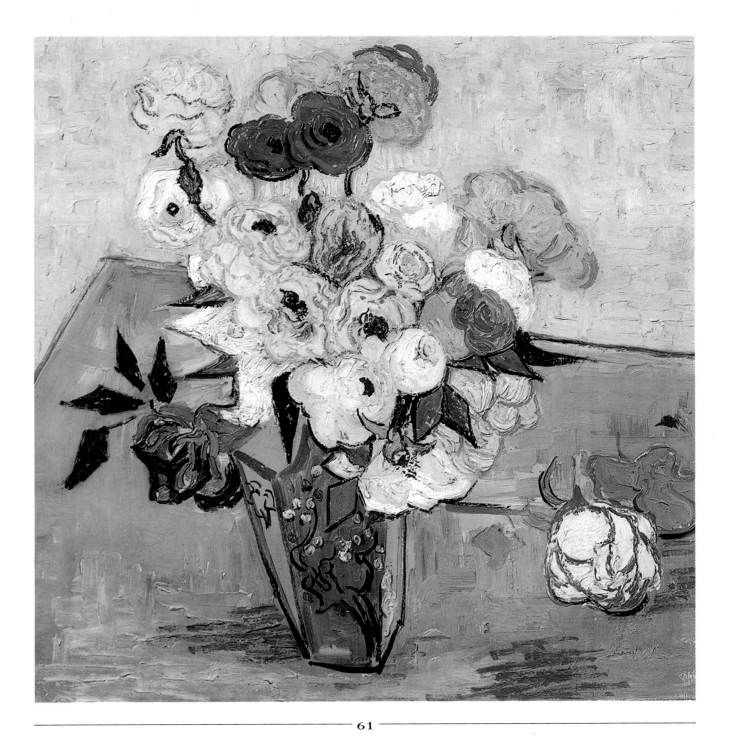

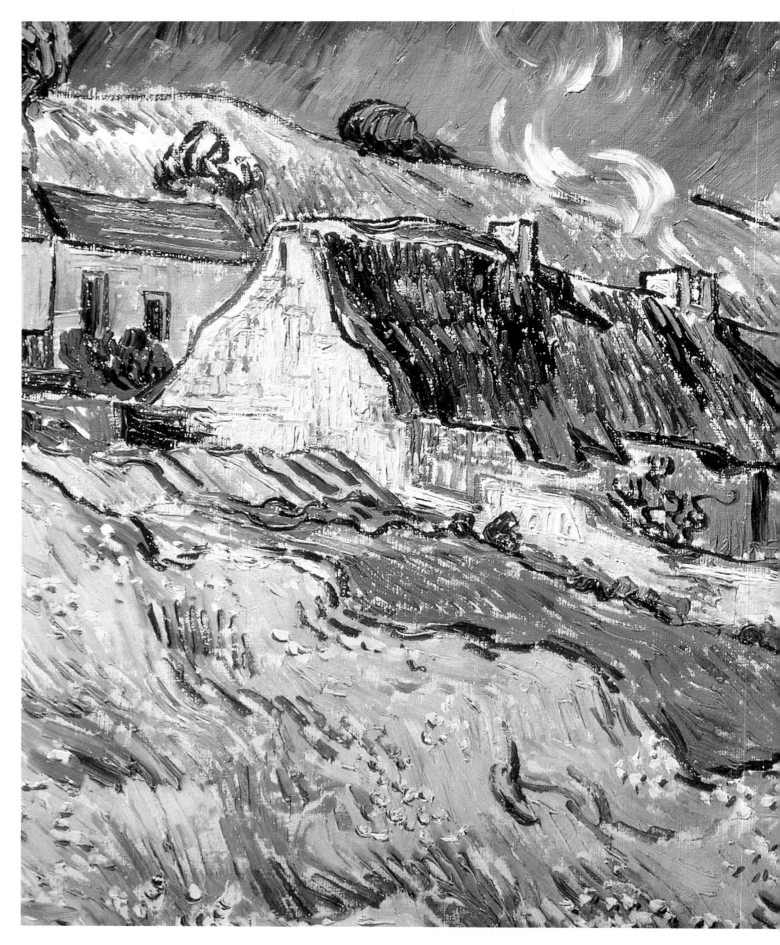

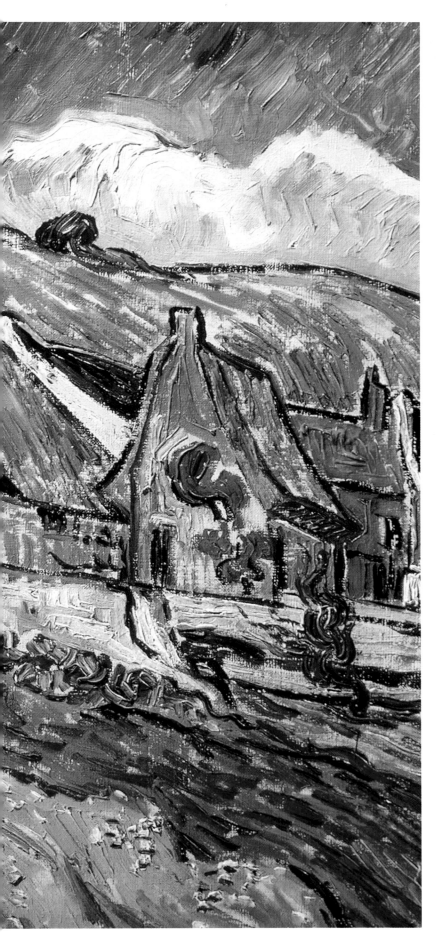

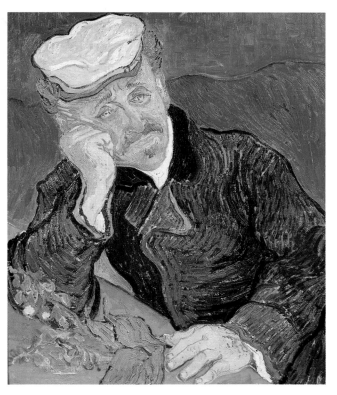

PLATE 45

Thatched Cottages (1890) left

Oil on canvas, 23²/₃ x 35³/₄ inches (60 x 91cm)

Painted while Van Gogh was under the care of Dr. Gachet and when he was allowed, in fine weather, to work in the countryside, this painting echoes some of Vincent's earlier preoccupations with the peasant life but is now executed in the bolder brushwork of his last phase. By this time he is able to create his images with assurance. In these landscapes, the sun – such a dominating feature in Arles and the south of France – is less evident, being replaced with cooler colour.

PLATE 46

Portrait of Doctor Paul Gachet (1890) above

Oil on canvas, 26³/₄ x 22¹/₂ inches (68 x 57cm)

Paul Gachet was an amateur painter as well as a heart specialist, who had been recommended to Theo by Pissarro as someone most suitable to look after Van Gogh. Theo evidently liked Gachet although Vincent was suspicious of him and not altogether friendly. Gachet agreed to keep an eye on Van Gogh who was then living at an inn run by the Ravoux family. However, Gachet's clear concern for Van Gogh broke down his patient's reserve and they became friends. Van Gogh painted both the Ravoux and Gachet families a number of times during his last months in Auvers. This version is one of a number in similar pose that he painted – all of which show Gachet as a somewhat sad figure with a quizzical expression. As in other subjects that he painted several times, Van Gogh has here only altered the objects on the table-top.

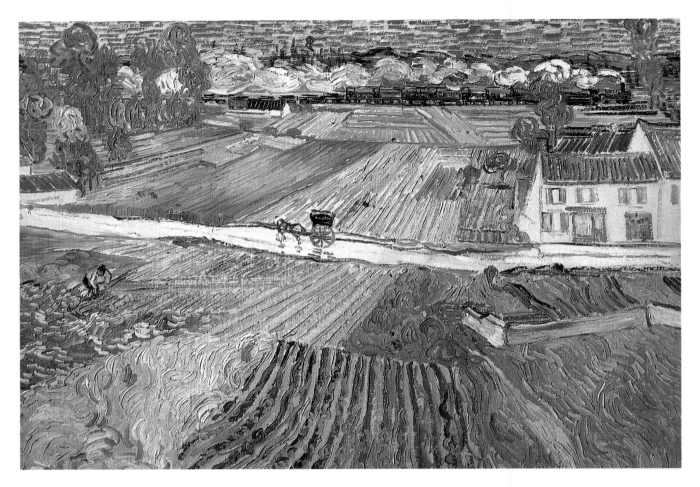

PLATE 47
Landscape at Auvers after Rain (1890)
Oil on canvas, 28$\frac{1}{3}$ x 35$\frac{1}{2}$ inches (72 x 90cm)

In this work, several of the characteristic features of Van Gogh's painting during the Arles period are present. We have already noted the symbolism of the rail train (plate 37), here less clearly seen because of the great volume of smoke that belches from its smoke stack and forms a frieze across the upper part of the picture. It will be noted that this train is going from left to right while the last did the reverse. There is an interesting general point to be made in this context: since in the West we read from left to right we tend to do the same with paintings so that the psychological effect of suggested movement is either sympathetic or the opposite, very often without our being consciously aware of the fact. There is more movement and imbalance in this painting than in the previous work and there is a curiously wet look to the whole scene which is difficult to explain. The most positive after-effect of rain is what seems to be the wet reflective road on which the cart is travelling. It might also be noted that the train is too large in scale for the amount it recedes into the landscape which gives it an importance which visually and actually it would not have had, and emphasizes the picture plane – the surface identity.

PLATE 48
The Prisoners' Round (1890) opposite
Oil on canvas, 31$\frac{1}{2}$ x 25$\frac{1}{4}$ inches (80 x 64cm)

Van Gogh's underlying and continuing concern for the poor and deprived came to the surface when he encountered the Gustave Doré print which formed the basis for this work – a more or less direct copy. The subject is the exercise yard of London's Newgate Prison in the middle years of the 19th century, which was one of a set of illustrations made by Doré for Blanchard Jerrold's book London: A Pilgrimage, *in which he explored the seamier sides of life. Doré was a highly successful painter and a moderately effective sculptor who died in 1883 only a few years before Van Gogh. The subject must have had a personal resonance for Van Gogh as he was in the asylum at St.-Rémy when he made this work and feeling the oppression of confinement as he wrote to his brother, 'I have been a patient for more than a year... I can't go on, I am at the end of my patience, my dear brother, I can't stand any more.'*

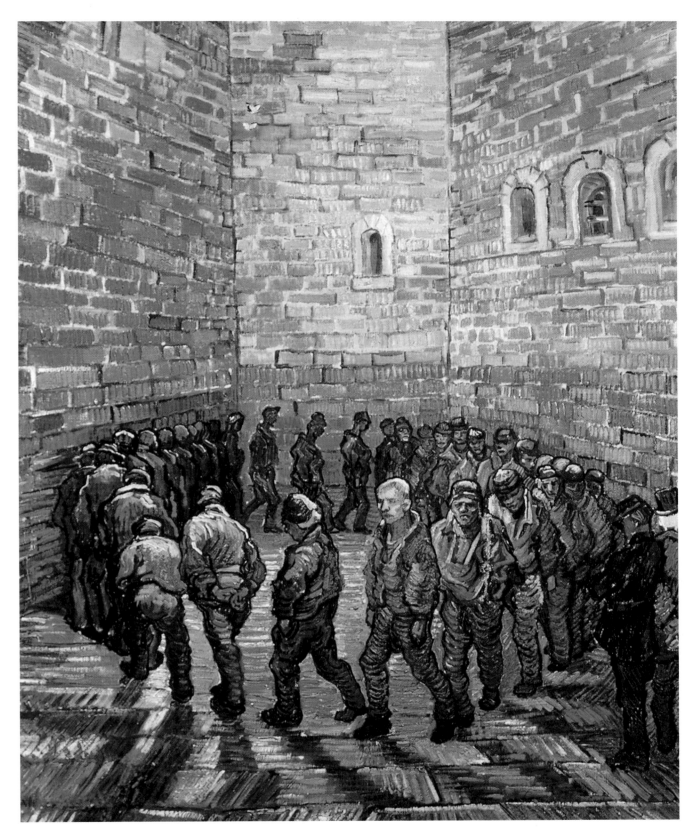

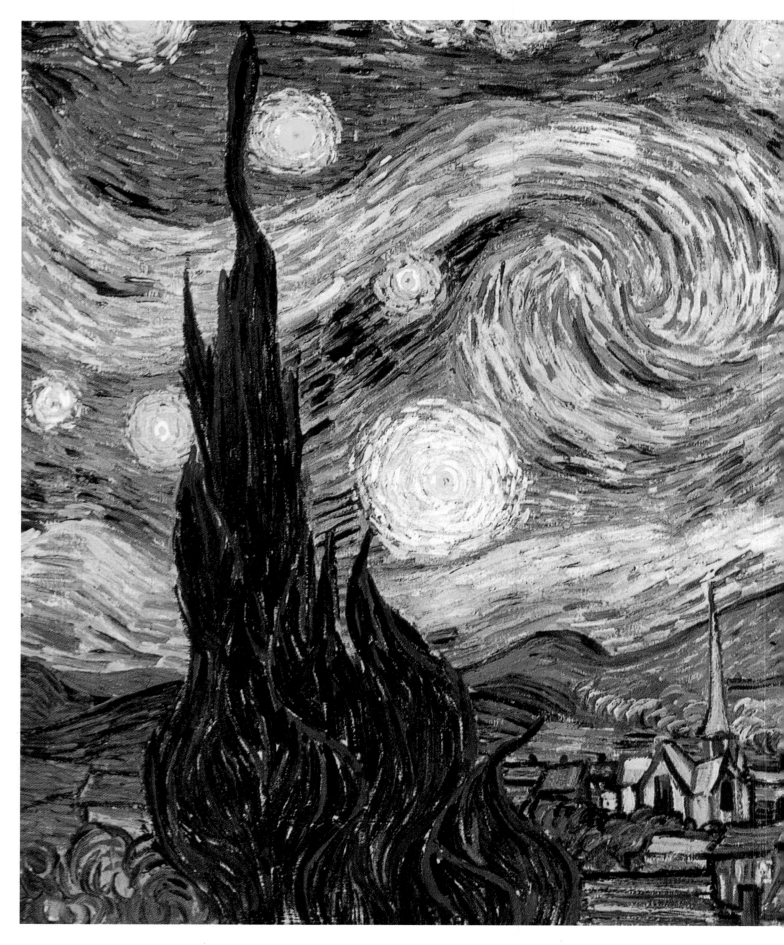

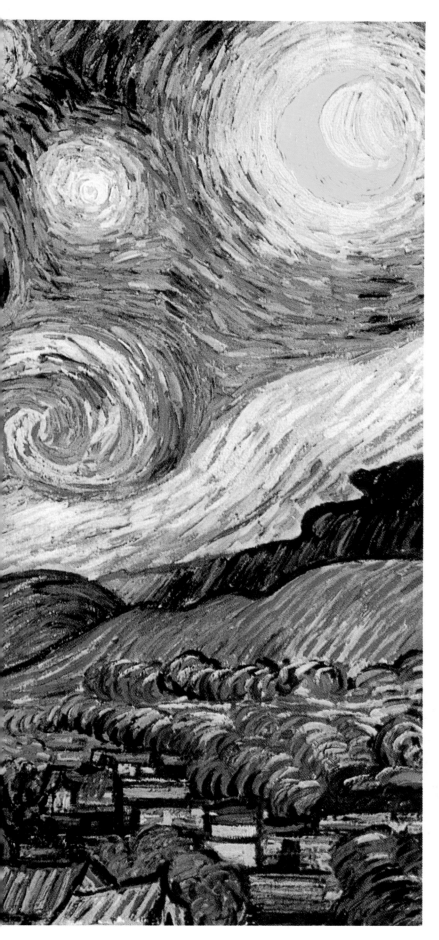

PLATE 49
Starry Night with Cypresses (1889)
Oil on canvas, 28³/₄ x 36¹/₄ inches (73 x 92cm)

The stars in the heavens at night, the moon, cypresses and distant mountains are all popular elements in Van Gogh's paintings but few are combined as they are in this turbulent image. The over-scale stars and the swirling meteors dominate the scene illuminated by the brightest crescent moon so that the town seems a small-scale model and the straining cypresses a gigantic menacing force. One is surprised that Van Gogh could control the act of painting the simple townscape in the face of the demands from the sky.

PLATE 50
Cottages with Thatched Roofs (1890)
Oil on canvas, 28¹/₃ x 35³/₄ inches (72 x 91cm)

Towards the end of his stay at Auvers, Van Gogh became very agitated and his mental instability more evident. It resulted in paintings in which the quiet peaceful landscape seems in turbulent motion almost as if in a whirlwind vortex. This is just one example of a number of paintings he made in the villages near Auvers at this time.

PLATE 51
Street in Auvers (1890)
Oil on canvas, 28³/₄ x 36¹/₄ inches (73 x 92cm)

This view of a street on the outskirts of Auvers is freely drawn and painted with directional brushstrokes in the foreground which draw the eye into what is essentially a rural scene. The colour is bright and the sky only roughly indicated with a few broad strokes, leaving much of the canvas unpainted. This does not mean that the work is unfinished but that Van Gogh's statement is complete. As can be seen by reference to other paintings illustrated, Van Gogh's technique varies greatly and he worked at great speed and intensity. It is probable that in earlier times he would have covered all areas of the painting but in his Auvers period there are many paintings similar to this.

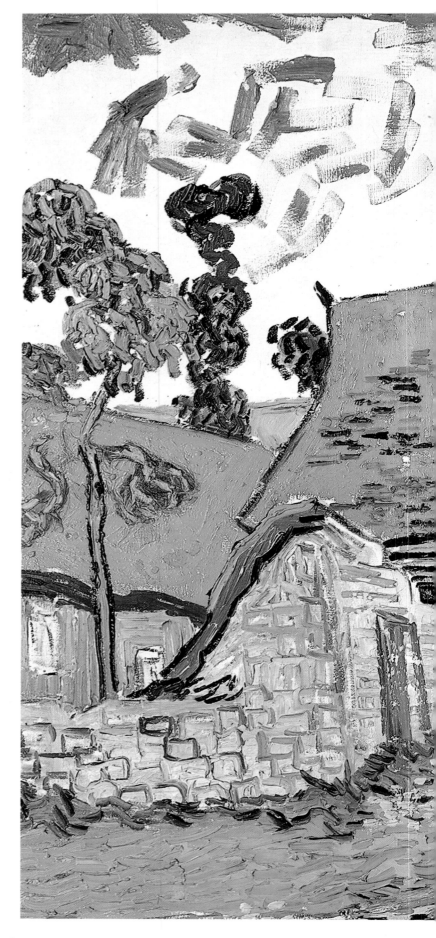

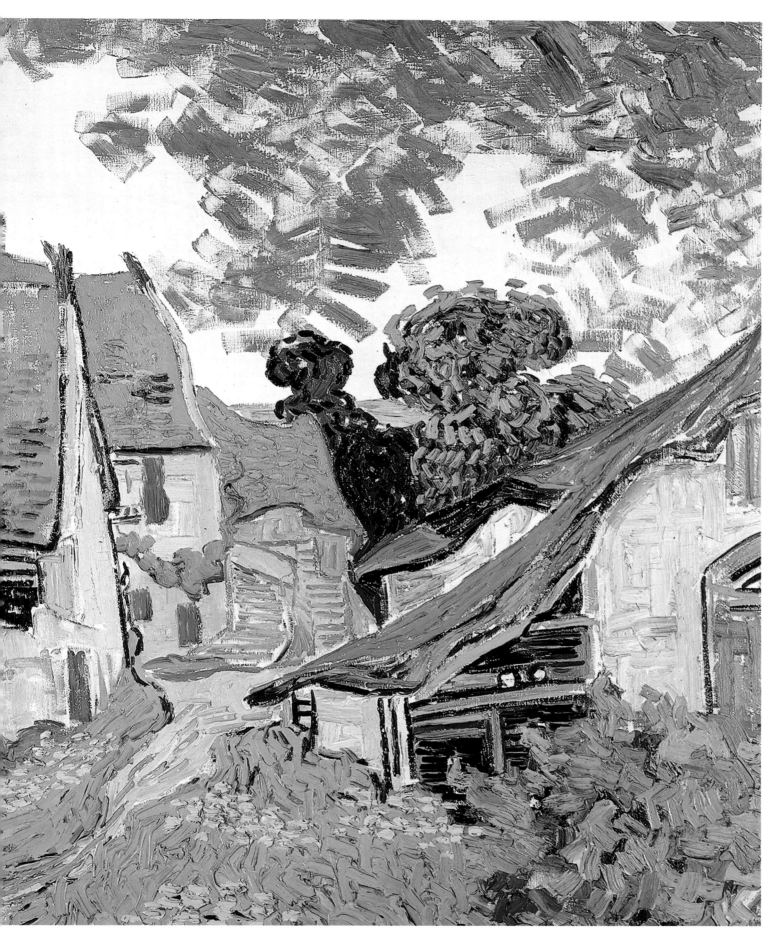

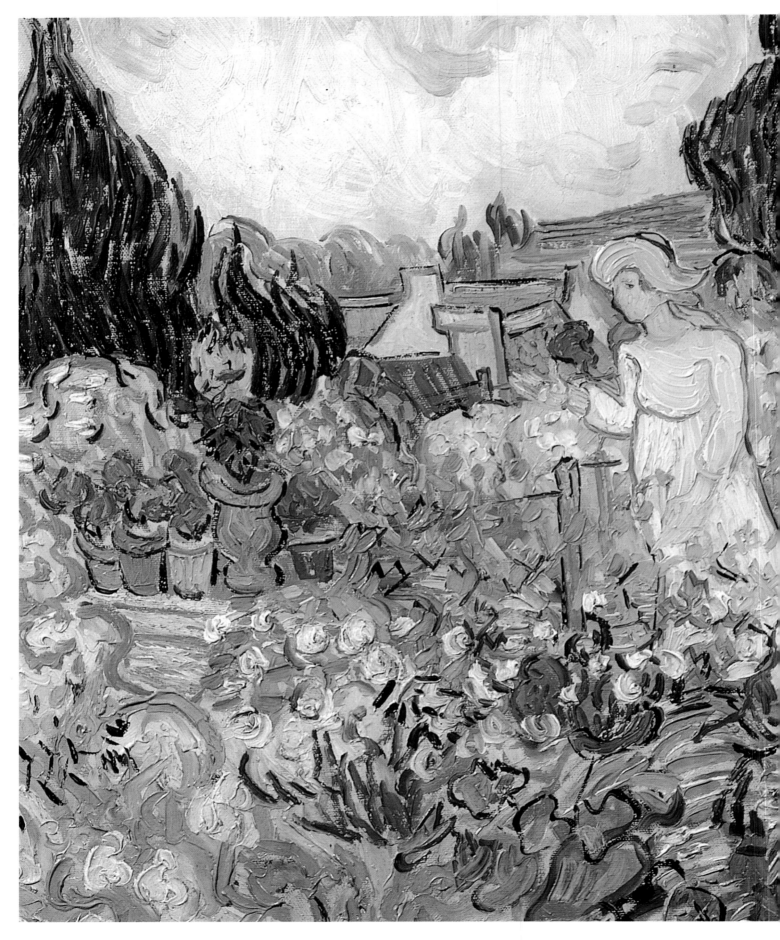

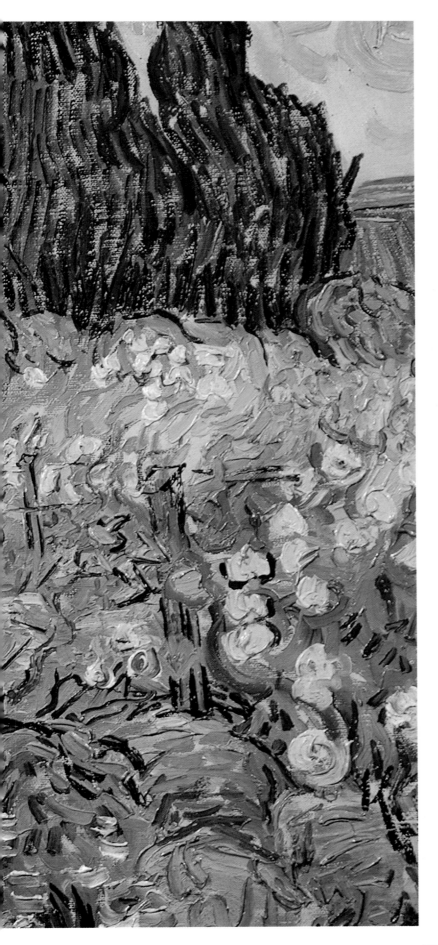

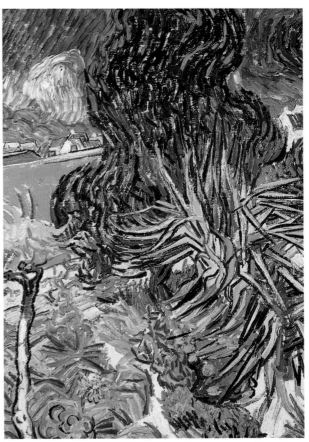

PLATE 52
Mademoiselle Gachet in Her Garden (1890)
left
Oil on canvas, 18¹⁄₈ x 21²⁄₃ inches (46 x 55.5cm)

*Soon after he arrived at Auvers and was placed under Dr.
Gachet's care, Van Gogh began to paint in Dr. Gachet's garden
with even more inflamed passion than he had in Arles and the
more northerly landscape and harsher weather darkened and
enriched his palette. This painting of the doctor's daughter,
Marguérite Gachet, in the garden, is much less disciplined and
carefully constructed than even the work he had completed only a
few months earlier. Present are cypresses, flowers and buildings
but they are lacking integration. The figure of Mlle. Gachet is
sketched, rather than drawn, and Van Gogh painted a more
controlled portrait of her later.*

PLATE 53
Doctor Gachet's Garden (1890) above
Oil on canvas, 28³⁄₄ x 20¹⁄₄ inches (73 x 51.5cm)
(See also note to plate 46.)

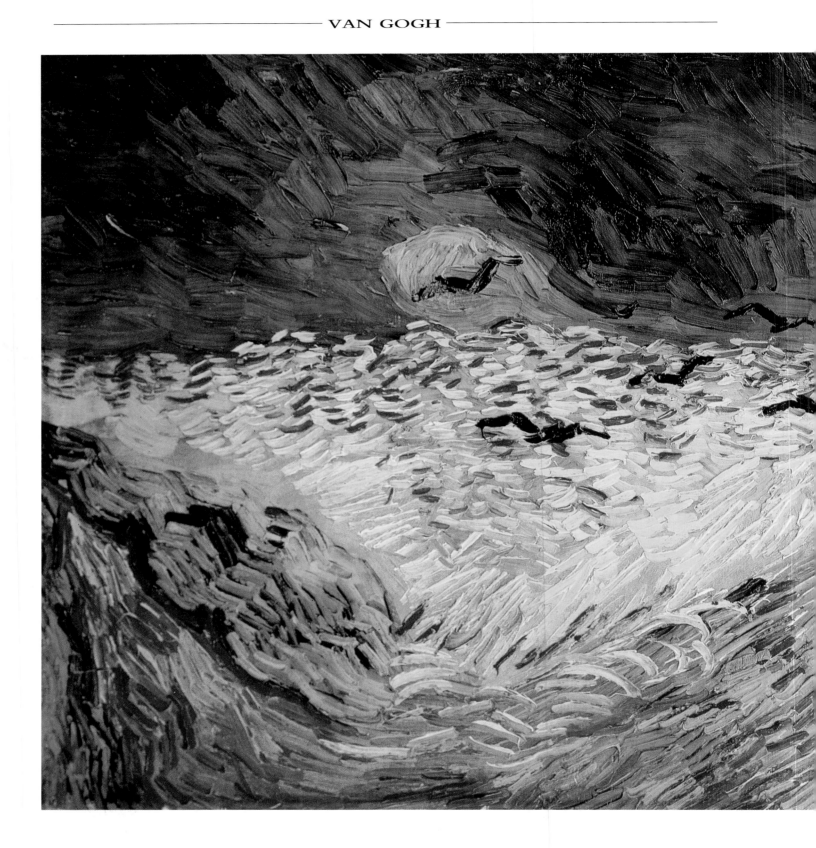

PLATE 54
Crows over a Wheatfield (1890)
Oil on canvas, $19^7/_8$ x $40^1/_2$ inches (50.5 x 103cm)

This last painting was produced on 27 July after which Van Gogh shot himself. Without realizing that he was fatally wounded, he returned to the Ravoux inn where he collapsed and died two days later. The poignancy of the work thus established, it is interesting to try to guess the state of Vincent's mind before his suicide from examination of the work. It bears study. Apart from the uncontrolled violence of both colour and paint application, its construction shows a spirit at the end of its tether. The two paths of the painting of the

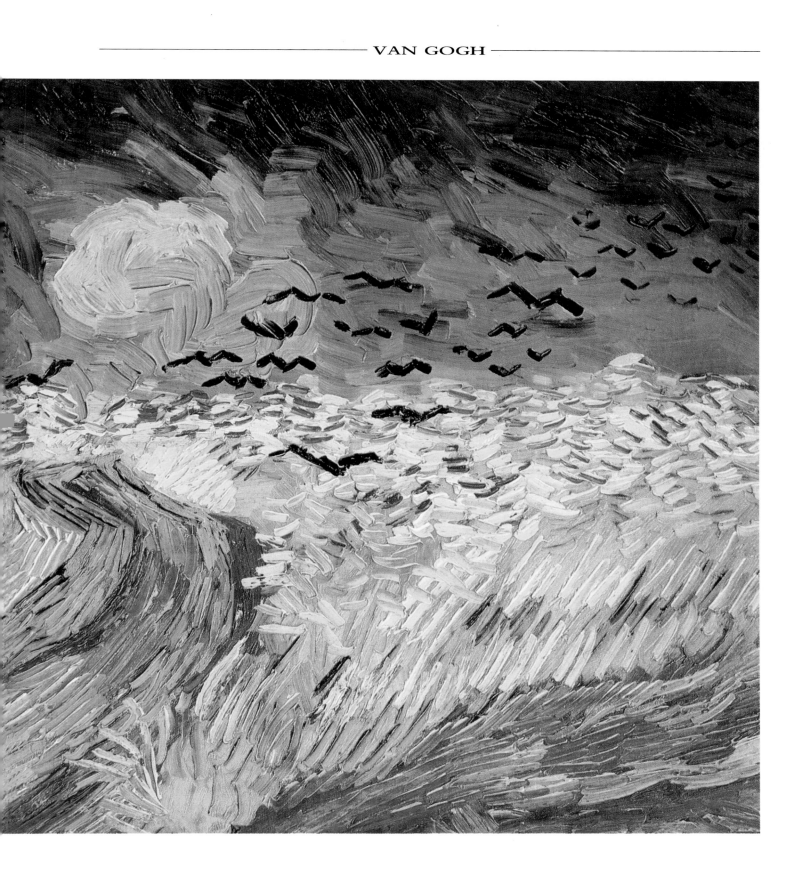

church at Auvers (plate 43) indictate a mind torn in two directions
whereas, in this, it appears to be divided three ways, by paths, right,
left and centre, symbolizing too many impossible decisions. And
hovering over the scene the crows, the black harbingers of death
looming out of a dark forbidding sky. Without knowing beforehand
that this was his last work, all this might still be deduced.

ACKÑOWLEDGEMENT

The Publishers wish to thank the following for providing photographs, and for permission to reproduce copyright material. While every effort has been made to trace and acknowledge copyright-holders, we wish to apologize should any omissions have been made.

Young Girl in Wood
Rijksmuseum, Kröller-Muller, Otterlo

The Weaver/The Loom
Christie's, London, Bridgeman, Giraudon, Paris

Road near Nuenen
Trewin Copplestone

The Potato Eaters
Van Gogh Rijksmuseum

La Guinguette in Montmartre
Musée d'Orsay/Lauros/Giraudon, Paris

Fritillaries in a Copper Vase
Musée d'Orsay/Lauros/Giraudon, Paris

Le Moulin de Blute Fin
Art Gallery and Museum, Kelvingrove

Le Moulin de la Galette
National Gallery, Berlin/Giraudon, Paris

Self-Portrait
Musée d'Orsay/Lauros/Giraudon, Paris

Wheatfield with a Lark
Van Gogh Rijksmuseum/Bridgeman/Giraudon, Paris

Père Tanguy
Musée Rodin

The Restaurant of La Sirène at Asnières
Musée d'Orsay/Giraudon, Paris

Sunflowers
Metropolitan Museum, New York/Lauros/Giraudon, Paris

The Yellow Books
Private Collection, Switzerland/Giraudon, Paris

Dance Hall at Arles
Musée d'Orsay/Lauros/Giraudon, Paris

L'Arlésienne: Portrait of Mme. Ginoux
Musée d'Orsay/Giraudon, Paris

Promenade at Arles (Souvenir of the Garden at Etten)
Hermitage Museum, St Petersburg/Giraudon, Paris

Public Gardens at Arles
Private Collection, U.S.A./Giraudon, Paris

The Café Terrace on the Place du Forum, Arles, at Night
Rijksmuseum, Kröller-Muller, Otterlo

Seascape at Les Saintes-Maries
Pushkin Museum, Moscow/Giraudon, Paris

The Lilac Bush
Hermitage Museum, St Petersburg/Giraudon, Paris

Les Alyscamps, Arles
Rijksmuseum, Kröller-Muller, Otterlo

Pollarded Willows with Setting Sun
Rijksmuseum, Kröller-Muller, Otterlo

Sunflowers
National Gallery, London

Gipsy Encampment near Arles
Musée d'Orsay/Giraudon, Paris

Starry Night over the Rhône
Musée d'Orsay/Giraudon, Paris

Camille Roulin
São Paulo Museum of Art/Giraudon, Paris

Cypresses
Metropolitan Museum, New York/Lauros/Giraudon, Paris

Doctor Félix Rey
Pushkin Museum, Moscow/Giraudon, Paris

Sower with Setting Sun
Rijksmuseum, Kröller-Muller, Otterlo

The Drawbridge Across the River at Arles with Washerwomen
Rijksmuseum, Kröller-Muller, Otterlo

Van Gogh's Chair with His Pipe
The National Gallery, London

Van Gogh's Room at Arles
Art Institute of Chicago/Giraudon, Paris

The Evening Walk
São Paulo Museum of Art/Giraudon, Paris

The Postman Roulin
Kunsthaus, Zurich/Giraudon, Paris

Irises
J. Paul Getty Museum

The Harvest
Musée Rodin, Paris/Flammarion/Giraudon, Paris

The Green Wheatfield with Cypress
Narodni Gallery, Prague/Giraudon, Paris

Self-Portrait
Musée d'Orsay/Giraudon, Paris

Landscape near Auvers
Neue Pinakothek, Munich/Lauros/Giraudon, Paris

Wheatfield with Stacks
Academy of Arts, Honolulu/Giraudon, Paris

Midday
Musée d'Orsay/Giraudon, Paris

The Church at Auvers
Musée d'Orsay/Giraudon, Paris

Roses and Anemones
Musée d'Orsay/Giraudon, Paris

Thatched Cottages
Hermitage Museum, St Petersburg/Giraudon, Paris

Portrait of Doctor Paul Gachet
Musée d'Orsay/Giraudon, Paris

Landscape at Auvers after Rain
Pushkin Museum, Moscow/Giraudon, Paris

The Prisoners' Round
Pushkin Museum, Moscow/Giraudon, Paris

Starry Night with Cypresses
Museum of Modern Art, New York

Cottages with Thatched Roofs
Musée d'Orsay/Giraudon, Paris

Street in Auvers
Atheneum, Helsinki/Giraudon, Paris

Mademoiselle Gachet in her Garden
Musée d'Orsay/Giraudon, Paris

Doctor Gachet's Garden
Musée d'Orsay/Lauros/Giraudon, Paris

Crows over a Wheatfield
Van Gogh Rijksmuseum